THE COLOR RESOURCE
COMPLETE COLOR GLOSSARY

Other books by Miles Southworth
Color Separation Techniques, 3rd Edition
Pocket Guide to Color Reproduction, 2nd Edition

Other books by Miles Southworth and Donna Southworth
Quality and Productivity in the Graphic Arts

Other books by Thad McIlroy
Desktop Publishing: A Primer for Printers
Desktop Publishing in Black and White & Color
The Quick Printer and Desktop Publishing

THE COLOR RESOURCE

COMPLETE COLOR GLOSSARY

By Miles Southworth, Thad McIlroy
and Donna Southworth

T H E C O L O R R E S O U R C E™

The Color Resource Complete Color Glossary

By Miles Southworth, Thad McIlroy and
Donna Southworth

ISBN 1-879847-01-9

© 1992 by The Color Resource

All rights reserved.

Cover and page design by Fortunato Fong
Output at 400 dpi to a NewGen TurboPS/400p
Printed by Bookcrafters

Published by

The Color Resource
3100 Bronson Hill Road
Livonia, NY 14487
(800) 724-9476
(716) 346-2776
FAX: (716) 346-2276

Table of Contents

Introduction
 The Words: Understanding Color Prepressix
 How to Use This Glossaryxiv
Glossary ..1
Product List ...217
Bibliography ..221
About the Authors ...223

Introduction

The Words:
Understanding Color Prepress

After years of stability, color prepress is an industry in upheaval. It had been built upon the well-understood science of color lithography, devoted to understanding how cyan, yellow, magenta and black inks could be used to simulate a broad spectrum of color. Desktop publishing changed all of that. First it introduced the world of computers to the world of prepress. Next it added typography. Finally the complexities of color imaging science became a vital link to appreciating desktop color prepress. Where color was once a single discipline, it now represents multiple fields, including computer graphics, color imaging, video, rendering, desktop publishing and typography.

The terminology of professional color prepress has always been a challenge. Terms like color gamut, densitometry, electronic dot generation, Newton rings, saturation and specular highlight, were never obvious in their meaning. The many professionals who have mastered this vocabulary are now faced with a vast number of foreign words pulled from the world of computers and desktop publishing. The desktop publishers who are new to color have a lot of work to do to understand the concepts behind the terminology of color reproduction.

The Color Resource

The Color Resource is responding to the challenge with *The Color Resource Complete Color Glossary*. It's a substantial revision of Miles and Donna Southworth's 1987 volume, *Glossary of Color Scanner, Color System and Communication Terms* (Livonia, NY: Graphic Art Publishing Company). That book contained about 350 terms; *The Complete Color Glossary* contains over 1,100. What a difference five years makes!

Assembling the glossary proved to be a far more challenging task than anticipated. The finished volume offers testimony to the fact that there's a lot more to color reproduction today than most people assume.

A unique vocabulary

We always take the language we speak for granted. It's hard to stand back for a moment and consider how our language sounds to newcomers. Just look at the following prepress terminology, and remember what these words meant when you were still a child.

The fields are converging

With the introduction of color desktop publishing, color prepress has become a marriage of various disciplines, including computer graphics, color imaging, video, desktop publishing and typography. Each of these fields has its own rich vocabulary, in most cases a vocabulary not widely understood by print professionals. For example, we've added more than 50 typographic terms to the glossary, and several dozen terms that are from the more theoretical fields of color graphics and color imaging.

Complete Color Glossary

Words Misunderstood

Word	What it Means to Color Prepress	What it Means to Everyone Else
bleed	ink running past the trim	to shed blood
blues	one-color proofs	a style of jazz
choke	image size reduction	to impede breathing by constricting the windpipe
driver	software to control a printer	a person who drives
dupe	a duplicate piece of film	a person easily deceived
mouse	a pointing device	a small rodent
RIP	raster image processor	to tear
TIFF	a raster file format	a petty dispute
Windows	a user interface for IBM computers	wall openings spanned with glass
WORM	write-once, read many optical disc format	an invertebrate with a long, round body

The Color Resource

New fields are encroaching

Color prepress is in flux. The science continues to develop. Today's hot new topic is data compression, with its related terminology: JPEG, Huffman encoding, lossy and lossless compression. The field of 3-D rendering looms as a new contributor to color imaging and will bring with it another full set of terms.

Product names become words

Most people have seen Xerox Corporation's advertisements protesting the use of the term "xeroxing" as synonymous with photocopying. On the other hand Scitex executives don't appear to be upset when they hear a designer talk about Scitexing an image. The use of the term "Scitexing" creates the impression that the only process available for image retouching is the Scitex one. Likewise, I doubt that the executives of Linotype-Hell see red when they hear a publisher ask for Linotronic output, as if there were no other type of imagesetter output available.

The spread of product names into color conversation is even more a matter of the dazzling array of trademarked names becoming a part of the everyday vocabulary. Cromalin and Color-Key equal proofing, PageMaker and QuarkXPress equal page makeup, and yet each of these products have important proprietary features that have to be distinguished in a glossary.

Complexity has become the currency of color communication

How many color prepress practitioners understand the difference between CIELUV, CIE L*a*b* and CIE XYZ? How many care? Yet the differences between them are central to an appreciation of the modifications to PostScript that Adobe has built into PostScript Level 2. Considerations of color space were never a large concern in traditional CEPS. By and large these systems appeared to work exclusively

Complete Color Glossary

with CYMK data. Computer graphics, however, is an RGB world, and desktop color is more the child of computer graphics than it is of CEPS. Converting color data from device to device and from RGB to CYMK and back has become critical to the future of color publishing. Hence you will find entries in *The Complete Color Glossary* for color space, gamut compression, CIE, CIE L*a*b*, CIELUV, etc.

The process is ongoing

The terms included in this first edition of *The Complete Color Glossary* are a snapshot collection, the collection arbitrarily halted at the end of 1991, just before going to press. The process of collection continues, as we prepare for the second edition, and we invite readers to let us know which additional terms should be added to maintain our claim to being the complete color glossary.

Acknowledgements

Special thanks to Steve Hannaford, Neil McLean and Stan Rosen for reviewing the proofs and offering so many valuable suggestions for improvement. Fortunato Fong did a fine job with the cover and interior page design, as did Sandra Jackson with the illustrations. Andrea Clough caught our numerous gaffs and typos at the proofreading stage.

Miles Southworth, Thad McIlroy and Donna Southworth
—January, 1992

How to Use This Glossary

There are over 1,100 words defined and cross-referenced in this book. We have tried to be straightforward and non-technical in our definitions.

For the most part, products are defined separately in a section at the back of this glossary, but we have included key product names, such as Cromalin and PageMaker, in both sections.

Pronunciation for some words is provided at the beginning of a definition, in brackets, i.e. (ASS-key) for ASCII. The syllable spelled with capital letters indicates where the emphasis falls in pronunciation. Words in italics within a definition can be found separately defined. Look to these definitions to amplify the meaning of the word you want to understand better.

Where a definition has an exact equivalent, you are directed to "see" that other word or term. Where another word or term can amplify a definition, you are directed to "see also" the other words or terms.

pronunciation guide

words in italics have separate entries

INIT

(IN-it) Abbreviation for INITial, a small *utility* program that loads automatically upon starting up a *Macintosh* computer. See also *cdev*.

see this reference for additional information

ΔE
See *delta E*.

3 point curve control
The technique of adjusting the *contrast* or *gradation* of a *color scanner* by making adjustments in three points on the *tone* scale, namely the *highlight*, *middletone* and *shadow*.

4-stop photography
See *measured photography*.

5 point curve control
The technique of adjusting the *contrast* or *gradation* of a *color scanner* by making adjustments in five points on the *tone* scale, namely the *highlight*, *quartertone*, *middletone*, *three-quartertone* and *shadow*.

8-bit color
The bare minimum of *color* information in a color computer *monitor*. 8-bit color offers the user 256 possible *colors*. This is not a wide enough range for high-quality graphic arts reproduction.

24-bit color

24 *bits* of computer information are the minimum required to define the *color* range that is used in professional graphic arts processes. For each *color* of *red, green and blue*, or *cyan, magenta* and *yellow*, 8 *bits* are used.

32-bit color

The 32-*bit color* definition includes 8 *bits* each for *cyan, magenta, yellow* and *black pixels*, or 8 *bits* each for *red, green and blue* pixels and 8 *bits* for a *mask* layer or other future uses.

5000K

The intensity of the light source in *standard viewing conditions* used for evaluating *transparencies* or *reflection copy*.

A0, A1, A2, A3, A4, A5, A6, A7 and A8
International Standards Organization *(ISO)* page size dimensions, based on portions of a square meter, that are used as international ad print guidelines. The length to breadth ratio is maintained through each division of the basic A0 size—see also *B0, B1, B2, B3, B4, B5, B6, B7, B8, B9* and *B10*.

Name	Size in inches	Size in millimeters
A0	33.11 x 46.81	841 x 1189
A1	23.39 x 33.11	594 x 841
A2	16.54 x 23.39	420 x 594
A3	11.69 x 16.54	297 x 420
A4	8.27 x 11.69	210 x 297
A5	5.83 x 8.27	148 x 210
A6	4.13 x 5.83	105 x 148
A7	2.91 x 4.13	74 x 105
A8	2.05 x 2.91	52 x 74

AA
Abbreviation for author's alterations, indicating that the cost of a change will be borne by the author, designer or publisher, rather than by the printer, typesetter or trade shop—see also *PE* and *editorial changes*.

AAAA
Abbreviation for American Association of Advertising Agencies—referred to as "the four A's."

absorptance
The relationship of the light absorbed by a surface to the total light striking the surface. A person is able to see *colors* because a portion of the light striking the surface of the scene is absorbed and a portion is reflected to the eyes. In printing, for example, *red* is achieved because the *magenta* and *yellow dots* absorb the *green* and *blue* light respectively leaving only *red* light reflected from the paper. The absorbed amount of a certain *color* of light determines the *hue* and *lightness* or darkness of the *color*. See *subtractive color theory*.

achromatic
Having no *color*.

achromatic color removal (ACR)
See *GCR*.

Accurate Screens™
The *rational screen angle* system incorporated in *Adobe*'s *PostScript Level 2*.

ad complaint
A publisher's or advertiser's formal grievance about the quality of the printed advertisement that is filed with the printer.

A/D converter
A device or *software* to convert an analog signal to a digital signal, used in data processing.

addition
See *extension*.

additive color primaries

The *colors red, green and blue*. When *white light* is broken down into its component parts, a rainbow *(visible spectrum)* is created. Dividing the rainbow into approximately equal thirds results in *red* light, *green* light and *blue* light. By combining (adding) the three *colors* of light together, *white light* is created.

additive color theory

The mixture of *red, green and blue* light, the *primary colors* of light, to produce *white light*. *Red* light, *green* light and *blue* light are each approximately ⅓ of the *visible spectrum*. *Red* and *green* light projected together produce *yellow*. *Red* and *blue* light produce *magenta*. *Blue* and *green* light produce *cyan*. *Yellow, magenta* and *cyan* are the subtractive *color* primaries.

Adobe Illustrator®

See *Illustrator*.

Adobe Photoshop™

See *Photoshop*.

Adobe Systems Incorporated

The Mountain View, California-based company that created, maintains and markets PostScript and PostScript-compatible products, including Adobe *Illustrator*, Adobe *Photoshop*, and a range of Adobe *PostScript fonts*.

Adobe Type Manager™

See *ATM*.

agate

A *system* of measurement still widely used in newspaper design. Fourteen agates equal one inch.

The Color Resource

airbrush

A *color* imaging *system* function that adds or removes printing ink content in a designated picture area. The operator uses the airbrush function by guiding a *stylus* on a *digitizing tablet* and by adjusting the electronic spray strength, speed and width.

AI

Abbreviation for artificial intelligence, a defined branch of computer science where computers are programmed to mimic human thought processes, rather than just make step-by-step calculations. The term is often used by marketers as a synonym for "sophisticated *software*." In the graphic arts, the science of *artificial intelligence* is just beginning to appear.

Aldus Corporation

The Seattle, Washington-based *software* company that publishes *PageMaker software* and was an influential developer of the market for *desktop publishing*.

Aldus FreeHand®

See *FreeHand*.

Aldus PageMaker®

See *PageMaker*.

Aldus Prep

A *file* included with *Aldus PageMaker*. This *software* contains information used by the program to improve *PostScript* printer and *imagesetter* results.

algorithm

A sequence of exact instructions that define a method to solve a particular problem. For example, algorithms are used

to create a digital *halftone screen*—see also *data compression, Huffman encoding, JPEG, LZW, run-length encoding (RLE),* and *screen algorithms.*

aliasing
In computer graphics, the process of offsetting a portion of a line to the closest available *pixel* causing *jaggies*, the stepped or jagged edge—see also *anti-aliasing.*

American National Standards Institute (ANSI)
See *ANSI.*

American Standard Code for Information Interchange
See *ASCII.*

analog data
Nondiscrete values of variables, such as voltages, amperages and *density*, rather than digitized discrete numerical values. Analog data may be digitized for storage. Analog is the opposite of digital—see *digital data.*

analog scanner
A computer or other device that manipulates *analog data* as variable voltages. Some *scanners* utilize hard-wired electronic circuits to do analog *color correction* and *tone reproduction*; other *scanners* utilize *digital data* to do similar functions—see *digital scanner.*

annulus
The small aperture that passes the image signal data during scanning. The annulus is surrounded by a larger *unsharp masking* aperture or mirror.

 The Color Resource

ANSI

(AN-see) Abbreviation for American National Standards Institute, the U.S. agency formally charged with the responsibility of establishing and maintaining industry standards. Volunteer committee members meet and decide on the standards. ANSI is the U.S. member of the International Standards Organization *(ISO)*—see also *IT8/WG11 committee* and *standard viewing conditions*.

ANSI standards

The following standards have been developed by the IT8 Committee:

• User Exchange Format (UEFF00) for the Exchange of Color Picture Data Between Electronic Prepress Systems via Magnetic Tape (DDES00) - IT8.1-1988, approved July 5, 1988.

• User Exchange Format (UEF01) for the Exchange of Line Art Data Between Electronic Prepress Systems via Magnet Tape (DDES00) - IT8.2-1988, approved December 14, 1988.

• User Exchange Format (UEF02) for the Exchange of Geometric Information Between Electronic Prepress Systems via Magnetic Tape (DDES00), IT8.3-1990, approved March 9, 1990.

• Device Exchange Format for the On-Line Transfer of Color Proofs from Electronic Prepress Systems to Direct Digital Color Proofing Systems, IT8.4-1989, approved October 27, 1989.

• User Exchange Format (UEF03) for the Exchange of Monochrome Image Data Between Electronic Prepress Systems via Magnetic Tape (DDES00), IT8.5-1989, approved December 15, 1989.

anti-aliasing
On low-resolution devices, a method for smoothing the jagged appearance of the edges of objects, such as type and line art. On a computer *monitor* anti-aliasing is achieved by partially lighting intermediate *pixels*—see *aliasing*.

APD
Abbreviation for Aldus Printer Description file, a *file*, used by *Aldus software*, that contains information on a specific output device. An APD includes data on type of paper, paper feed mechanism, printer *resolution*, etc. The use of APDs has largely been supplanted by *PPDs*.

Apple Computer Inc.
The Cupertino, California-based computer company that manufactures and markets the Apple and *Macintosh* brands of personal computers.

application
Any *software* program, that applies a set of routines to handle a specific task. Microsoft Word and *Aldus PageMaker* are examples of applications.

APR
Abbreviation for automatic picture replacement, a term used by Scitex to describe a feature in its *desktop-to-prepress* system for replacing low-resolution *viewfiles* with high-resolution scanned images. APR functions much like *OPI*.

archival storage
The maintenance of a permanent record of images (text, graphics or pictures), on a medium such as photographic film, magnetic tape or optical disc. Archival storage is retained until intentionally destroyed, removed or altered.

area mask
An *outline mask* that isolates a specific area of an image either by shape, *color* or *tone* value.

argon laser
A very strong, collimated, directional bluish-colored light that is used to expose images onto *orthochromatic* or *blue* sensitive photographic film, paper or *printing plates*. The spectral output peaks at 470 *nanometers*. The advantage of an argon *laser* over a *helium neon laser* is that the argon *laser* can image *blue* sensitive film, which can be used with a *red* or *yellow* safelight—see also *helium neon laser*.

array processor
A computer that can calculate a new value for each *byte* stored in a data array to create a new data array. Many simultaneous calculations can be made at high speed—see *RIP*.

artificial intelligence
See *AI*.

ascenders
The lines of lower case type that extend above the body of the letter, such as on a "b" or a "d."

ASCII
(ASS-key) Acronym for American Standard Code for Information Interchange, the international standard codes that are used by most computers to symbolize letters, numbers, punctuation and certain special commands. Files are often saved in the ASCII *format* for translation to other computers or for *modem* transmission. The ASCII set doesn't include notation for paragraph formats or for text formatting, such as bold or *italic*, so when a *file* is saved in ASCII *format*, a lot of information in the *file* may be lost.

assembly

Traditionally, the process of attaching film components of pages in their correct position to a carrier sheet of film, goldenrod paper or plastic. A *printing plate* is exposed using the page *imposition*. Electronic assembly is the process of placing all pictures, tint blocks, text and line work in their proper locations within a digital page file.

ATM™

Abbreviation for Adobe Type Manager, a software program that improves the display of fonts on video displays.

author's alterations

See *AA*.

automatic picture replacement

See *APR*.

B0, B1, B2, B3, B4, B5, B6, B7, B8, B9 and B10

International Standards Organization (*ISO*) page size dimensions, based on portions of a square meter, that are used as international ad print guidelines—see *A0, A1, A2, A3, A4, A5, A6, A7* and *A8*.

Name	Size in inches	Size in millimeters
B0	39.37 x 55.67	1000 x 1414
B1	27.83 x 39.37	707 x 1000
B2	19.68 x 27.83	500 x 707
B3	13.90 x 19.68	353 x 500
B4	9.84 x 13.90	250 x 353
B5	6.93 x 9.84	176 x 250
B6	4.92 x 6.93	125 x 176
B7	3.46 x 4.92	88 x 125
B8	2.44 x 3.46	62 x 88
B9	1.73 x 2.44	44 x 62
B10	1.22 x 1.73	31 x 44

background processing

Computer calculations that take place in a plane behind and separate from the foreground plane being used by the computer or *system* operator. This allows the operator to continue his/her interaction with the computer without delay.

backup

An extra copy of computer work that is kept on a separate *disk* or *disks* for safety's sake in case anything happens to the original.

Balanced Screening

A system for determining high quality PostScript *halftone screen angle*s, developed by Agfa Corporation. Balanced screening consists of precalculated screen descriptions that are downloaded to a *RIP*, rather than the algorithms characteristic of other screening technologies. See also *HQS* and *IntelliDot*.

banding

1. Perceptible steps in a computer-generated graduated tonal fill.
2. Smooth gradations of *halftone dots* interrupted by strips of greater than, or less than, desired *density* caused by irregular film motion within *imagesetters* or film recorders. The stripes of irregular *density* run perpendicular to the direction of travel. *Contouring*, rather than being directional, is an unwanted darkening of areas that follow image densities—see *contouring*.

bandwidth

The amount of information that can pass through a *system*. An optical *filter* might pass wavelengths of light from 400-500 *nanometers*; an electronic circuit or computer might operate at 15 *megahertz*, a measure of cycles per second.

baseline

In typesetting, an imaginary line on which the bottom of letters rest. The *descenders*, such as the tails on y and g, fall below the baseline.

BAUD or baud

(Bawd) 1. The rate of data transmission for information sent across a telephone wire, or between computers. Over phone lines, the most common speeds today are 1200 baud and 2400 baud, with 9600 and 19,200 baud gaining acceptance in the *color* prepress industry. The higher the baud rate, the faster you can send information.

2. The *bandwidth* of the shortest pulse in the data stream. If the data transmission is binary, baud and *bit* rates are roughly the same.

beam splitter

An optical device to redirect a beam of light in two or more directions. A *color scanner* splits the input light into *red, green and blue* light beams and directs each to a *PMT*. The output beam splitter separates the light into as many as ten beams, one to each *modulator*.

benday

A method of pasting down screened *tone* percentages on the illustrations, artwork, etc. to be photographed. These *screen tints* are usually on pressure sensitive plastic sheets with a release backing, and are used to create a tonal or *dot* pattern, and eliminate the need for an overlay.

Beta or Betamax

A home video *format* that is used on ½ inch magnetic tapes. Although Beta is of slightly higher quality than *VHS format*, it has not become popular.

beta site

A first-user test site for computer *software* or *systems*. Users at the beta sites usually obtain *software* for little or no money in exchange for reporting any problems encountered during the beta test period.

Bezier curves or Bézier curves

(Bez-ee-aa) Curved lines that are used in *CAD* and computer illustration for *drawing* and type rendering. The line is defined by anchor points. These points set the shape of the curve but are not necessarily part of the line itself.

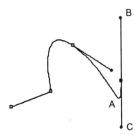

To redefine the curve at point "A", the designer manipulates either point "B" or point "C", rather than the curve itself.

Bézier curves

bidirectional interface

A connection between two pieces of equipment that allows the transmission or reception of data in either direction. *Scanners* are sometimes connected to *color electronic prepress systems* with bidirectional interfaces to enable the *scanner* to output the film as well as input data to the *system*.

bit

The smallest, or basic, unit of stored information in a computer expressed as a binary notation, either a one or a zero. Eight bits make a *byte*. A *byte* represents a value or *character*. Some computers use 16 bits and 32 bits for more computing power.

bitmap

A series of individual *dots* or *pixels* that define graphics. On a *color* or black-and-white *system*, a bitmap defines a *character*

or an image by turning each *pixel* on or off. Each *pixel* must be recorded for a full image. *Paint programs* use this *format* and are different than *vector graphics*, which define graphics by points.

bitmap graphics or bitmapped graphics

Describes the image that is displayed on a computer *screen*. The image is composed of a series of individual *dots* or *pixels*. Each *dot* on the *screen* corresponds to a *bit* in the *screen buffer* and, therefore, is called mapped. The *screen buffer* is an area in the *RAM* memory of the computer. Early computer drawing *software* used bitmapped graphics. Although more precise than *vector graphics*, bitmapped graphics are slower and require more *RAM*.

Detail of bitmapped letter "A"

black

1. The absence of all reflected light caused by printing an ink whose colorant gives no apparent *hue*.
2. One ink in four *color* process printing

black box
A *conversion unit* that accepts input data and alters it for output.

black printer
The *plate* made during the prepress printing process that is used with the *cyan, magenta* and *yellow* printers to enhance the *contrast* and to emphasize the neutral *tones* and the detail in the final reproduction *shadow* areas—also called *key*—see *full-scale black* and *skeleton black*.

bleed
Extending an image beyond the finished trim size so that the image runs right to the edge of the printed sheet after trimming and binding—see also *full bleed*.

blue
Describes the *color* of a clear sky.
1. A *primary color* of light.
2. A portion of the *color* spectrum aligned between *green* and violet.
3. In printing, a *secondary color* resulting from *overprinting dots of cyan* and *magenta process color* inks—see *additive color primaries* and *additive color theory*.

blueline
A single-color photographic *proof* of *negatives* that shows how the printed reproduction will appear. The actual *color* to be displayed is not exhibited. However, by varying the *exposure, color breaks* can be indicated—also called blues, brownline, brown print, Dylux, silverprint, VanDyke and *Velox*. These names were derived from the chemically coated papers that are exposed to create an image and washed with water to desensitize them. Depending on the type of *proof* made, the image is *blue* or brown.

blues
See *blueline*.

boldface
A type style that is heavier, thicker and blacker than the regular typeface. Bold can be in *italic* format as well as *roman*.

bounding box
In a *page description language*, such as *PostScript*, the defined rectangular area within which an image is contained.

bpi
Abbreviation for *bits* per inch.

bps
Abbreviation for *bits* per second, a rate of data transfer over telephone lines between *modems* — see *BAUD*.

brightness
1. The amount of light being reflected from a surface.
2. In a printed reproduction, the *lightness* value regardless of the *hue* or *saturation*. Brightness is affected by the reflectance of the paper. This is not called brilliance.

broadband
See *wideband*.

Brunner
See *System Brunner*.

buffer
A computer memory area that is used for the temporary storage of data waiting to be processed—see *frame buffer*.

bullet

A small solid circle. When positioned at the beginning of a line of type, a bullet usually indicates that the line is part of a list of items. Bullet size is determined by point size.

bulletin board

In computer communications, a dial-in data storage area containing messages, files, *software*, etc. Trade shops and publishers often establish bulletin boards that their customers can access by *modem* on a 24-hour basis.

bundled software

Software that is included with a computer or computer *system* as part of the total purchase price.

byte

Eight *bits* of stored information, or 256 discrete levels of data. In electronic publishing, each byte represents a value or *character*.

C or C language
A popular computer programming language that is often used to create graphics *software*.

C band
A telecommunications electronics *frequency* that limits information to 6,010 *gigahertz* for the *uplink* to a satellite and to a 4.0 *gigahertz bandwidth* for the *downlink* to a ground station.

C print
A photographic print made by exposing a *color negative* to photographic paper that is sensitive to all *colors* of light. This should not be confused with a *dye transfer print*.

cache
See *RAM cache*.

CAD
Acronym for computer-assisted design. CAD is usually used in reference to architecture or engineering renderings.

CAD/CAM
Acronym for computer-assisted design/computer assisted manufacturing, the catch-all category for the use of computers in the design and engineering processes.

Calibrated RGB color space

A set of *video monitor* specifications that define a *red, green and blue* phosphor set, a WhitePoint and the opto-electronic transfer function included in Adobe *PostScript Level*. WhitePoint is the lightest neutral white that the output device is capable of rendering in a way that preserves *color* appearance and visual contrast.

calibration

See *color calibration*.

CAM

Acronym for computer assisted manufacturing.

camera-ready art

Text and graphics assembled in position, ready to be photographed for film *assembly*—sometimes called camera-ready copy—see also *mechanical*.

capstan imagesetter

See *flatbed imagesetter*.

carbon wedge

A small *transparent gray scale* made on a strip of film. A carbon wedge increases in *density* from clear film to a *maximum density*. The minimum to maximum variation may be in incremental steps, or it may be continuous. The scale is made using a carbon dispersion coating that has very fine grain with low light scattering characteristics. This attribute makes the carbon wedge suitable for *scanner* calibration. A photographic *step tablet* will scatter light rays and is not as useful in the *scanner* specular optics.

cast

See *color cast*.

Complete Color Glossary

CCD

Abbreviation for charged-coupled device, a very small light-sensitive photocell that is sensitized by giving it an electrical charge prior to *exposure*. CCDs have a broad range of uses in optical devices such as video cameras, photocopiers and scanners. CCDs sense the amount of light from an image during the scanning of an image. CCDs are extremely small; each is several thousands of an inch as compared to a *PMT*, which is the size of a radio tube. This small size makes it possible to use CCDs in *desktop scanners*. CCDs often have difficulty distinguishing small *color* and *tone* differences in the dark *shadow* areas, and are generally considered inferior to *photomultiplier tubes* for use in scanners.

CCD array

A linear arrangement of charge-coupled devices *(CCDs)*. In a *scanner*, a straight row of charged-coupled devices, which may only be one inch long, scan and measure the light from as many as 1024 points.

CCD scanner

A black-and-white or *color scanner* using a *CCD array*.

CD

Abbreviation for compact disc, a small round optical storage media containing audio information. Other forms of CD, such as *CD-ROM*, derive from the audio CD format.

cdev

(SEE-dev) Abbreviation for control device, an *INIT* or *utility* program that loads automatically and is usually used to control *peripheral* devices, such as *scanners* or *CD-ROM* drives.

CD-ROM

Abbreviation for compact disc read-only memory, a storage media for information, such as *utility* and *applications*

 The Color Resource

software, that can be accessed (read), but cannot be altered or written onto the *disc*. CD-ROMs store up to 600 *megabytes* of material and are identical in appearance to audio compact *discs*. Musical *CDs* are CD-Roms with read-only data — see *CD* and *ROM*.

cell
See *halftone cell*.

center
See *quad center*.

centimeters to inches
To convert centimeter measurements to inch measurements divide the number of centimeters by 2.54 (2.54 centimeters equal 1 inch).

central processing unit
See *CPU*.

CEPS
(seps) Abbreviation for *color* electronic prepress *system*, a *high-end* computer-based *system* that is used to *color* correct *scanner* images and assemble image elements into final pages. Although the configurations and *peripherals* making up a CEPS used for graphic arts applications may vary, each CEPS is used to accomplish what can be done manually with duplicate transparencies and *emulsion stripping*. CEPS should not to be confused with *high-end scanners* that *color* separate but do not assemble pages. The abbreviation CEPS is sometimes used to refer to a *color electronic publishing system*.

CGA
Abbreviation for *color* graphics adapter, a low *resolution color* video card for IBM-style computers. The CGA makes it possible to display four *colors* at a 200 x 320 pixel *resolution*.

CGATS
(SEE-gats) Abbreviation for Committee for Graphic Arts Technology Standards, an *ANSI*-accredited, U.S. standards organization. The primary responsibility of CGATS is to provide overall standards coordinating activities for the graphic arts industry and to provide graphic arts input to existing standards developers. CGATS works on writing standards only where no other standards committee is already working. The committee's activities include the development of a glossary to help standardize graphic arts terms, the definition of *color* measurement practices for the graphic arts, graphic arts densitometry standards and *plate* dimension standards as well as a cooperative activity to move portions of *SWOP* to an *ANSI* standard.

CGM
Abbreviation for computer graphics metafile, an *ANSI*-endorsed *file format* that can define both *raster* and *vector graphics* in one *file*.

character
Any letter, number, space or mark that is used in text.

character count
The total number of individual letters, numbers, punctuation, spaces and other *characters* in a section of text.

characters per inch
See *CPI*.

characters per pica
See *CPP*.

character set
The complete collection of letters, numbers, punctuation marks and special *characters* that comprise a specific *font*.

charge-coupled device
See *CCD*.

chokes and spreads
See *spreads and chokes*.

Chooser
A *Macintosh desk accessory* used to designate a specific printer, *imagesetter* or other output device as the current output device.

chroma
The attribute of *color* that specifies its amount of *saturation* or strength in the *Munsell color space* model.

ChromaCom™
The brand name for the *color electronic prepress system* marketed by Linotype-Hell Company.

chromaticity diagram
See *CIE Chromaticity Diagram*.

chrome
A slang term referring to a *color transparency* that is used as the *original copy*. Chrome is incorrectly used as a short term for *Cromalin*.

Cibachrome
Photographic *color emulsion* type films and papers used to make *color* transparencies and prints. Cibachrome is manufactured by Ilford Photo Corporation.

Complete Color Glossary

CIE

Abbreviation for Commission Internationale de l'Eclairage, an international organization that in 1931 defined a visual *color model*. This group established the specifications for the standard observer *color* vision sensitivity. These specifications are the basis for all colorimetric measurements of *color*. The readings taken for *red, green and blue* are the *tristimulus values* of X, Y and Z.

CIE Chromaticity Diagram

A two-dimensional plotting of the *CIE* three-dimensional *color space*.

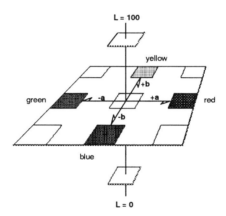

CIE Chromaticity Diagram

CIE color space

A three-dimensional mapping *system*, such as CIELUV and CIELAB, that is used to locate or plot the three *color* attributes. A *colorimeter* is used to measure the X, Y and Z *tristimulus values* from which the three-dimensional *systems* are calculated. CIELAB, CIE L*a*b*, and CIELUV use L or L* to represent the *lightness* or darkness value, ± A, a* or U to represent the red-green attribute value and ± B, b*

The Color Resource

or V to represent the yellow-blue attribute value. These *color* spaces are similar to the *Hunter L,a,b Color Solid System*.

CIELAB
See *CIE color space*.

CIELUV
See *CIE color space*.

CIE XYZ
The *tristimulus* values from which the three-dimensional *systems*, such as CIELAB and CIELUV, are calculated—see *CIE color space*.

clean room
An enclosed space pressurized to keep dust particles from entering the room atmosphere where *high-end CEPS* are in use — see *environment*.

clip art
Noncopyrighted illustrations, *characters*, figures, cartoons, photographs and designs that can be purchased in printed form, or digitally on floppy *disks* or *optical discs* for use in artwork.

clipboard
A part of memory where blocks of text or graphics are temporarily stored after they are cut or copied. Anything stored in the clipboard can be copied from there and pasted into another document. The clipboard feature is standard on the *Macintosh* and with *Windows* 3.0 *software*.

clone
See *cloning, IBM-compatible computer* and *PostScript clone*.

Complete Color Glossary

cloning
An *image processing* function that is used to duplicate a *pixel* or many *pixels* from one area of a picture to another picture area. This *pixel* manipulation may add or remove detail. Some manufacturers call this function *pixel swopping*.

CLS
Abbreviation for Color Layout System, the Crosfield (DuPont) Lightspeed software program.

CLUT
Abbreviation for color lookup table, stored computer information that is used to translate from one *color space* to another. Rather than recalculating in each instance, preset values are referenced.

CMS
Abbreviation for *Color Management System.*

CMY
Abbreviation for *cyan, magenta* and *yellow process colors* or inks.

CMYK
Abbreviation for *cyan, magenta, yellow* and *black process colors*, or inks.

coarse data file
A digitized image *file* of an original scene that was sampled at the *resolution* of a *video monitor*, approximately 512 x 512 or 1024 x 1024 *pixels*, and used to make judgments about such things as the *scanner* setup or the quality of the *original copy*—also called a low resolution file or a *viewfile*. It contains less picture information than a high *resolution* picture

The Color Resource

file that is sampled at a minimum of four *pixels* per output *halftone dot*—see *high resolution file*.

coaxial cable
An electrical cable that is a single-center, copper wire surrounded by a woven metal shield. The shield acts as the second signal carrier to complete a loop. Coaxial cable is used for *Ethernet networks*.

cold color
See *cool color*.

color
The visual sensation of human response to seeing certain wavelengths of light. To see color, there must be a light source illuminating objects that absorb or reflect the light to the human eye. The color or colors seen depend on the quality of the light source, the object's light absorbability or reflectivity (the color of the object), and the sensitivity of the human eye.

color balance
Maintaining the ratio of *cyan, magenta* and *yellow* ink during printing. This will keep all *color hues* consistent and produce a picture with the desired *color*, one without an unwanted *color cast* or *color* bias.

color break
The process of dividing a *monochrome* representation of a page so that the appropriate areas will proof or print in the appropriate *color*.

color calibration
A procedure to standardize a *video monitor, input scanner* or output *color* printer to a standard set of values so that *WYSIWYG* (what you see is what you get).

color cast

An unwanted overall discoloration of an *original copy, color proof* or reproduction caused by an overabundance of one *color* pigment or light. *Color* casts result in bluish red, pinkish blue, etc. reproductions. The color cast can be digitally altered during or after scanning by using *gamma correction*.

color chart

A printed array of *color* patches that are used to choose, communicate and match *colors*. The *color* of each patch varies, one from another, and is made to given amounts of *cyan, magenta, yellow* and *black* inks or of premixed colors — see *ACS, Color Curve, Focoltone, Pantone Matching System* and *TRUMATCH* in product section.

color compression

1. The shrinking of the *color gamut* of an *original copy* to a *color gamut* reproducible with a given ink, selected paper and printing press configuration.
2. A technique to reduce the amount of data in a color image *file* by removing large amounts of redundant data—see *data compression*.

color computer

The part of a *color scanner*, or software in a computer, that computes the amount of each colorant, *CYMK* or *RGB*, necessary to reproduce the *color* being scanned. The determination may be based on the *masking equations*, the *Neugebauer equations* or lookup tables. The computer may be either analog or digital.

color control bar

A film test strip printed or exposed onto a film or *substrate* to produce an assortment of measurable *color* and gray patches that are used to measure and control the printing process and *proofing*.

color correction

A deliberate change of certain *colors* in the *original* when it is reproduced. The customer may have requested the modification, or it may be needed because of the colorants that were used to reproduce the image. Inks for *process color* are not pure *colors*; each appears as though it is contaminated with the other two *colors* and has a *hue error* that requires compensation in the *separation* images. The changes can be made electronically, photographically or manually so that the *separation* films produce the desired result—see also *retouching*.

color electronic prepress system
See *CEPS*.

color film recorder
See *film recorder*.

color gamut
The complete range of *hues* and strengths of *colors* that can be achieved with a given set of colorants such as *cyan*, *magenta*, *yellow* and *black* ink printed on a given paper and given printing press. Although it can represent strength, it usually represents *hues*.

colorimeter
An instrument for measuring the *tristimulus values* of *color* with a precise and defined response that is similar to the human eye. A *densitometer* can measure color strength, but is not a reliable indicator of color *hue*. Densitometers measure through separation filters which do not match the human visual response.

colorimetry
A science of *color* measurement.

Color-Key™
A 3M product for making *overlay color proofs*.

color lookup table
See *CLUT*.

color management system (CMS)
A suite of software *utility* programs capable of making the necessary color transforms from one *color space* to another to insure calibrated color.

color matching system
1. A *color chart* that has been printed or stored in an electronic *system* and is used to compare *color* samples—also called a *color swatching system*.
2. A computer-based process that can measure a *color* and formulate a new set of colorant amounts to reproduce the measured *color*. The *system* can be used to mix special *color* inks.

color model
A *system* for describing every *color* in a full *gamut* of *color* within a *color space*, such as *HLS (hue, saturation* and *lightness), RGB (red, green and blue)* or CIELAB *(lightness*, redness and blueness).

color negative
A *color* photographic film that was made from an *original* scene and is used to make a *color* print or *separation*.

color OK
See *OK sheet*.

The Color Resource

color palette
1. The assorted *colors* an artist or a *color system* uses or combines in varying amounts to make other desired *colors*. The artist places pigments on a board and blends them.
2. In a *color system* the range of colors available within a software program or within the computer *operating system*.

color portability
The ability to transfer *color* images or files from one device to another without significantly changing their appearance.

color proof
A visual impression of the expected final reproduction produced on a *substrate* with inks, pigments or dyes, or on a video *screen*—see *contract proof, DDCP, digital proof, hard proof, off-press proof, position proof, press proof, prog* and *soft proof*.

Color QuickDraw
See *QuickDraw*.

color reference
A standard set of process inks that were printed to standard densities or strengths on standard paper and are used for *color* control.

color retouching station
A computerized *workstation* with a color *video monitor*, usually *off-line*, that is used by an operator to electronically change a *color* image output from a *scanner* or *CEPS*. The data *file* is sent from the *CEPS*, the changes, such as *spot color*, overall *color* or image enhancement, are made, and the corrected *file* is sent back to the *CEPS* or output device. The *color* retouching station usually does not perform page *assembly*, scans or output.

Complete Color Glossary

color rotation
See *color sequence*.

color scanner
An electronic device that is used to produce *color separations* from *color original copy*. Each type of color scanner, or its *software*, analyzes the *original*, inputs the data from the *original copy*, compresses the *tones* for *contrast*, *saturation* and *brightness*, *color* corrects to produce the correct *color hue*, adjusts for the *gray balance* of the printing inks, increases the *sharpness* and enhances the detail for better *resolution*, and stores the corrected information in the temporary *buffer*. The corrected information may be transferred to a page makeup *system*, or it may be output as *halftone positives* or *negatives* at the correct size—see *drum scanner* and *flatbed scanner*.

color separation
The process of making a separate electronic or photographic record of the amounts of each *process color* of *cyan, magenta, yellow* or *black* needed to reproduce an *original copy*. The record may be a photographic film made through the *red, green and blue* separation *filters* or a computer *file*. A set of four separations, *cyan, magenta, yellow* and *black*, are required to reproduce an *original color* image, since each of the four *process colors* must be represented. The separations may be made photographically using traditional methods or digitally using electronic *scanners* and computer programs. The *original copy* may be a *transparency* (slide), reflection photographic print, drawing, painting or printed reproduction.

color sequence
On a printing press or *color proof*, the order of applying the *yellow, magenta, cyan* and *black* inks to the *substrate*.

The Color Resource

color space
A three-dimensional space or model into which the three attributes of a *color* can be represented, plotted or recorded. Although not always called by the names *hue, value* and *chroma*, these are the three *color* attributes represented—see *CIE color space* and *Munsell color space*.

color strength
See *saturation*.

ColorStudio™
A *software* program for the *Macintosh* that is used for image capture, *retouching*, *color correction* and *color separation*, published by Letraset.

color swatching system
See *color matching system*.

color system
See *CEPS, desktop color* and *midrange system*.

color temperature
The temperature in degrees *Kelvin* to which a *black* object would have to be heated to produce a certain color light. 2900K is representative of a tungsten lamp. 5000K is close to the temperature of direct sunlight and is considered the most critical attribute of *standard viewing conditions* for *color* evaluation.

color transparency
See *transparency*.

Complete Color Glossary

Combi
The generic name for the operator's workstation in the Linotype-Hell *ChromaCom* system. Combi is short for CombiSkop.

communications protocol
A specific set of instructions and *syntaxes* that regulate data exchange between computers and includes a provision for error checking.

comp
See *comprehensive*.

compact disk
See *CD*.

composite color file
Using *DCS*, five files are created—the composite color file and the four *color separations*. The composite color file contains a viewable low-resolution version of the color image.

comprehensive
A detailed *dummy* or sketch of a design, intended to give a client or the printer a clear sense of how the finished publication will or should look when reproduced. Desktop publishing systems can easily create *comps* using low-resolution black and white or color printers.

compression
See *data compression*.

computer color
See *8-bit color, 24-bit color* and *32-bit color*.

condensed
In typesetting, the compression of *font characters* widths without reducing their height—the opposite of *extended*.

connectivity
The ability to connect—establish communication. In electronic publishing, connectivity is used to describe a color *system's* ability to be connected to *workstations, peripherals,* storage and output devices so that an entire color page can be produced.

continuous tone
See *CT*.

continuous wedge
A narrow strip of film with an orderly progression of gray densities, ranging from zero to *maximum density*, without definite steps.

contone
Abbreviation for continuous tone. See *CT*.

contouring
A tendency of *pixels* with similar values to clump together when output. The effect in a reproduction looks like spots of darker *density* or *color*. When it appears as streaks across the image, it is called *banding*.

contract proof
A *color proof* that represents an agreement between the printer and the client regarding exactly how the printed product will appear.

contrast
1. The visual relationship of the *original* to its reproduction.

2. The visual tonal relationship between an original image and its reproduction. Each *density* in the *original*, from the *highlight* areas through the *middletone* areas to the *shadow* areas, will result in a corresponding reproduced density. A step tablet or gray scale is used to relate the changes in the densities. Big changes in the steps results in a "contrasty" reproduction, while small changes result in a *flat* reproduction. This relationship is also called *gradation*. The Greek letter γ (gamma) is used to represent a numerical value for contrast. It can be illustrated in several ways.

Contrast can be shown graphically by plotting the *densities* of an *original* on the x axis against the printed (reproduced) *densities* on the y axis. The slope of this plotted line represents the *gamma*. A perfect *gamma* of 1.0 is a 45° line that represents an exact reproduction of the original image. Any portion of the plotted curve with less than a 45° slope is said to be low contrast. Most often a color reproduction will have normal contrast in the *highlights* and *middletones*, and lower contrast in the *shadows*.

A *gamma* value is computed by either of two methods. A small triangle drawn on the straight line portion of the plotted gamma curve gives a value for x (run) and for y (rise). The γ value is determined by dividing y by x.

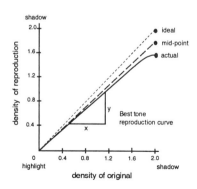

A gamma curve

 The Color Resource

Another method to calculate *gamma* is to divide the *density range* of the original (DR_O) into the *density range* of the reproduction (DR_R).

$$\gamma = \frac{\text{rise}}{\text{run}} \text{ or } \frac{DR_R}{DR_O}$$

conventional color angles
See *traditional color angles*.

conversion unit
A *black box interface* device that converts the electronic data *format* or *syntax* of one *system* to the electronic data *format* of another *system*.

cool color
A *color* that elicits a psychological response or impression of coolness—a *hue* in the range from violet through *blue* to *green*. A *color* reproduction is considered cool if the *color balance* or *gray balance* is adjusted to be slightly bluish rather than pinkish or gray.

copy
The *original* job material furnished for printing, comprised of paste-ups, transparencies, photographs and other graphics—also called *originals*, *camera-ready art* or camera-ready copy.

copyfitting
The process of determining the amount of space that text of a specific size and typeface style will use, in traditional typesetting. In *desktop publishing*, copyfitting is the process of altering type specifications (size and typeface style) in a block of text to ensure a proper fit in a preset area.

CPI

Abbreviation for characters per inch. Each typeface has a predetermined number of CPI at each point size. When the *character count* of a block of text has been determined, the number of *characters* that can be fit into each inch will determine the total line length. In *desktop* typesetting, *tracking* can be used to adjust the text to a given area.

CPP

Abbreviation for *characters* per *pica*, a measure that is used in typesetting. The significance of this term is the same as for *CPI*, only the measure is *picas*, rather than inches.

CPS

Abbreviation for *characters* per second, a measure of system input or output speed.

CPU

The arithmetic and logic unit of a computer that controls and processes data for a device. It is here that the main input and output circuits, and information processing chips including *RAM* and *ROM* are located. The CPU may also house *disk* storage. CPU is an abbreviation for central processing unit.

crash

An unexpected shut down of a computer program, *disk* drive or *peripheral*—see *disk crash* or *head crash*.

Cromalin™

A type of *single sheet color proof* that is used for verifying the *colors*, checking *register*, obvious blemishes and size of images. Cromalin is a trademark of DuPont.

 The Color Resource

crop
To cut, trim or eliminate a portion of the paper, image or *copy*.

crop marks
Symbols placed in the margin outside the image area that indicate to the printer the area to be printed and/or trimmed from the image during the binding/finishing process.

Crosfield
Crosfield Electronic Ltd., a UK-based company, one of the earliest manufacturers of *color scanners* and *CEPS*. Today, Crosfield is part of DuPont Imaging Systems, a subsidiary of DuPont and Fuji.

Crosfield Users Group, Inc.
An association of owners and operators of Crosfield prepress equipment—see also *users group*.

crossfeed
The movement of the input or *output optics* of a *high-end scanner* parallel to the cylinder axis.

crossover
Describes an illustration that covers parts of two facing pages in a book or magazine. It gets its name from the fact that it crosses over the binding edge. It is important that both parts of a *color* illustration line up on both pages when the book is assembled and that the *colors* match on both halves of the reproduction.

CRT
Abbreviation for cathode ray tube, the picture tube in a *video monitor*.

CT

Abbreviation for continuous tone.
1. In the printing industry, continuous tone describes an assortment of *tone* values that range from *minimum density* to *maximum density* in any amount. A CT image, such as a 35mm *transparency* or a photograph, does not contain *halftone dots*. CT can also refer to a scanned or computer generated picture *file* before it has been *screened*, in other words, before the image has been broken down into *dots* for printing on a press.
2. CT refers to the digital *system's bitmap file format* of scanned *original* images.
3. In the *Scitex system*, CT is the *file format* in which continuous-tone scanned images are stored.

CT2T

Abbreviation for Continuous Tone to Tape, a *Scitex format* and *protocol* specification for magnetic tapes that are used for recording and storing *continuous tone* images on *CEPS systems*.

cut and paste

A built-in function in the *Macintosh operating system* or *Microsoft Windows* with which a user can designate a portion of an image in one *file*, delete (cut) that portion, and copy it exactly (paste) into another *file*.

cyan

1. The subtractive *primary color* that appears blue-green and absorbs *red* light.
2. A blue-green ink that is used as one ink in the four *color* printing process — sometimes referred to as "process *blue*."

CYMK

Abbreviation for *cyan, yellow, magenta* and *black process colors*, or inks.

Dainippon Screen
see *Screen*.

DAT
Abbreviation for digital audio tape. DATs are now used as high-capacity data storage media.

data compression
A technique to reduce the amount of data in an image *file* by removing large amounts of redundant data. This process reduces the storage space and the transmission time required per *file*. *Algorithms* reduce the data in the image *file*, and restore the data, when the image is recreated from the data *file*. A compression ratio of 10 parts to 1 part of data can be done without losing important detail. Compressions of 30 to 1 have been done with some loss of detail. Some of the commonly used *algorithms* for data compression are *Huffman encoding, JPEG, LZW* and *run-length encoding (RLE)*.

data shuttle
See *removable hard disk drive*.

DCS
Abbreviation for *desktop color separation*, a data *file* standard defined by *Quark* to assist in making *color separations* with

desktop publishing systems. Using DCS five files are created. There are four color files, containing the cyan, magenta, yellow and black image data, and a *composite color viewfile* of the color image.

DDAP

(DEE-dap) Abbreviation for digital distribution of advertising for publications, an approved standard for electronically communicated ad files sent to publishers and printers for reproduction. Named by Dunn Technologies.

DDCP

Abbreviation for direct digital *color proof*, a *proof* produced on a *substrate* directly from the *digital data* stored in a picture or page *file* in a *CEPS* or *desktop* computer. A *peripheral* device utilizing a photographic *exposure*, dot matrix, electrophotographic thermal transfer or *ink jet* printer is used to produce the *color proof* without the need for *halftone* films. These *proofs* reduce the need for some of the traditional *color proofing* materials that are often used during the production cycle.

DDES

Abbreviation for Digital Data Exchange Standards, a set of established *protocols*, formats and values that allow one vendor's equipment to communicate with another vendor's *system*. This is an approved *ANSI/ISO* standard that is used by *high-end* vendors.

default

A standard computer setting designated by the *system* designer or by the user. The setting is permanent unless specifically changed by the operator. For example, word processing *software* will, by default, use a 12 point type unless the user changes the type size setting.

degauss

A process used to remove the magnetism from a color monitor. The magnetism can distort the appearance of the displayed colors.

degradé

(DEG-ra-day) A colored *halftone tint* that gradually changes in strength and *hue* from one edge to the other. It may vary in *hue* in both directions depending on which *process color tint* value changes. A *vignette* is only one *color* that varies only in strength *(brightness* or *lightness)*; one *color* appears to fade away. Degradés are sometimes called graded tints; and are incorrectly called gradations—see also *benday*.

delta E

Often written ΔE, a given amount of *color* change. Delta refers to the Greek letter Δ that is used to indicate changing characteristics. In *colorimetry*, it is common to use a scale to indicate the change in a *color hue* and strength. A reading can be taken by pushing a button on the *colorimeter* that automatically displays a computational value which represents the amount of *color* change. Industry research has shown that many customers will accept a variation in their printed products of six ΔEs.

densitometer

An electronic, *process control* instrument that is used to measure the *density* (darkness) of visual images and colorants. Colored ink or dye densities are measured through their complimentary *filter* to indicate their relative strength. A densitometer should not be used to indicate a point in a three-dimensional *color space* model. *Density* measurements are used to calibrate *color systems* and to control *color* processes.

The Color Resource

density

The visual darkness of a material caused by its capability to absorb or reflect the light illuminating the material. Density is measured with a *densitometer*. Colored materials are measured through their complimentary *filters*. Density differences are sometimes call *gray levels*. As density increases the amount of reflected or transmitted light is reduced. The amount of light absorbed is inversely proportional to the amount of light reflected from or transmitted through the sample. Density is represented by the equation:

$$\text{Density} = \log_{10} \frac{1}{\text{Transmittance}} \text{ or } \log_{10} \frac{1}{\text{Reflectance}}$$

density range

Means the same as *tonal range*, the maximum range of *tones* in an *original* or reproduction, calculated as the mathematical difference between the *maximum* and *minimum density* (the darkest and the lightest *tones*). For example, a *transparency* might have a 3.0 *shadow density* and a 0.25 *highlight density*. The lowest *tone* value, 0.25 is subtracted from the highest *tone* value, 3.0; the result is a 2.75 density range. A printed density range is 2.0 maximum or less.

descenders

The portion of a lower case letter that extends below the body of the letter, such as on a "p" and "q."

descreening

The process of removing a halftone *screen* pattern from an image, either optically or with the use of electronic filters. A new screen can then be added.

design station

A *workstation* that is used by an operator/designer to create an *original* image or page plan.

Complete Color Glossary

DesignStudio™
A *software* program for the *Macintosh* that is used for page makeup. DesignStudio was developed by Manhattan Graphics and is distributed in some countries by Letraset.

desk accessory
A *Macintosh utility software* that a user adds to the *Macintosh operating system*. It is always accessible, no matter which *application* is in use.

desktop
1. Refers to the size of a computer or *peripheral*. A desktop device is small enough to be used on a desk or table as a part of a *desktop publishing system*.
2. A desktop computer is a microcomputer, as opposed to a *minicomputer* or mainframe computer.
3. On the *Macintosh* graphic display, the area of the *finder* seen when the computer is first turned on, before any *application* is launched.

desktop color
The photomechanical reproduction of *color* accomplished by using a standard-platform tabletop computer that works with *PostScript*, such as a *Macintosh*, *PC*, NeXT or Sun *workstation*, linked with a *desktop flatbed color input scanner* and output *peripherals*, such as a *direct digital color proofer*, *laser printer*, and black-and-white *imagesetter*. The *color* image is scanned, viewed on the *monitor*, corrected, processed, stored, *imported* into a page make-up program, and output to a *color proof* and to *halftone* film. At the time of this writing, the *color* quality of *desktop systems* is not equal to the *color* quality of the *high-end CEPS*. It is possible to improve desktop *color* quality by selecting *input scanners*, *color proofing* devices and *imagesetters* of higher *resolution*. Usually for the highest quality desktop *color*, picture files are *imported*

 The Color Resource

from *high-end scanners*—see also *CEPS*, *desktop-to-prepress* and *midrange system*.

desktop publishing
The process of creating fully composed pages using a *standard platform* computer, *off-the-shelf software* and an output device. These components form a *system* that is driven by a *device-independent page description language*, such as *PostScript*. The pages, comprised of text and graphics, are output to a printer or *imagesetter*.

desktop publishing system
A *standard platform* computer, *off-the-shelf software* and an output device that are used to create composed pages. The *system* components use a *device-independent page description language* — usually *PostScript*. A desktop publishing system is one type of *electronic publishing system*.

desktop-to-prepress
The interchange of data files between a *desktop system* and a *CEPS*. Desktop-to-prepress *systems* are combinations of *software* and hardware that make this interconnectability possible.

detail enhancement
A scanning term, the technique of exaggerating picture image edges with the *unsharp masking* or *peaking scanner* control, so that the observer can see all the detail of the *original* in the reproduction—see also *unsharp masking* and *peaking*.

device independence
The characteristic of a computer *system* or program that allows different output devices to image the same *file* more or less identically. *PostScript* was the first major device-independent *page description language*.

Complete Color Glossary

device-independent color
A concept referring to *color* images that appear the same on different output devices, including *monitors* and various printers.

dichroic filter
A combination mirror and *filter* that allows certain predetermined wavelengths of light to pass through while reflecting other wavelengths. For example, the *filter* might pass *red* light but reflect *green* light.

diffraction grating
An optical device, made of very fine lines, that separates *white light* into its component parts creating a *color* spectrum.

diffuse highlight
The whitest neutral area of an *original* or reproduction that contains detail and will be reproduced with the smallest printable *dot*. Diffuse highlight should not to be confused with *specular highlight,* which is a direct reflection of a light source in a shiny surface, has no detail, and is printed with no *dot*.

digital camera
An image-capture device that captures and records a single image on an integrated circuit card or a *hard disk*. The image may be stored in an analog or digital format.

digital data
The *discrete values* of electronic information stored or transmitted as a series of ones and zeroes. The values can be mathematically computed, stored or transmitted accurately. This is not always possible with *analog data* that is represented by variable voltages and is susceptible to component

variation, which could cause less reliable results or inconsistencies. *Analog data* may be digitized for storage.

Digital Data Exchange Standards
See *DDES*.

digital distribution of advertising for publications
See *DDAP*.

digital fonts
Typographic fonts described either as *bitmaps* or by using *Bezier curves*.

digital hard proof
See *DDCP*.

digital photography
The process of capturing an original image with a camera that digitizes the image at some point in the process. This digital image may be displayed on a *video monitor*, manipulated and included in an electronically completed page.

digital press
A *lithographic* printing press designed to print from *plates* that have been digitally imaged either on or off the press using a data base. This allows for short *pressruns* of variable data with little or no *makeready* time.

digital proof
A black-and-white or *color* image reproduction made from digital information without producing intermediate films. A picture *file*, data *file* or *text file* can be represented by a *digital hard proof* made directly on a *substrate* using a *peripheral*

output device, or displayed as a *digital soft proof* on a *video monitor*—see *color proof* and *DDCP*.

digital scanner

An image scanning device that determines a digital discrete *gray level* or *density* for each *pixel* area scanned. A digital *color scanner* uses the digital values with *software* to do the necessary *color correction* and *gradation* changes. An analog *color scanner* uses analog voltages in hard wired circuits to make the needed *color correction* and *gradation* changes. Although digital scanners are preferred, there are many *analog scanners* being used.

digital screening

Halftone screens formed from *halftone dots* formed from *spots* created by a digital output device such as a *laser printer* or an *imagesetter*. The science of digital screening is complex and precise, and remains a developing technology in color prepress.

digital soft proof

A *color video monitor* display of a graphic data *file*.

digital unsharp masking

See *unsharp masking*.

digitizing tablet

A flat, smooth, rectangular surface that is sensitive to the location of its *stylus*. As the *stylus* is moved on the tablet, the

A digitizing tablet

usually recorded to a data *file*. Digitizing tablets are often used to translate the line work from a *mechanical* into a *CEPS*.

direct digital color proof
See *DDCP*.

direct-to-plate
Refers to digital imaging technology that allows composed pages to be output directly to *printing plates* rather than first to film.

disc
This spelling of the word disk is usually used in reference to *optical discs*, rather than digital floppy *disks*. See *CD, disk* and *WORM*.

discrete value
Something that varies only by whole, countable elements. For example, counting the number of light sources in the *scanner* rather than measuring the intensity of the light—see *nondiscrete value*.

disk
A flat, circular information storage medium with a magnetic surface on which information can be recorded, as compared to a *disc* that is an optical storage media.

A 3½" disk and a 5¼" disk

Complete Color Glossary

disk crash
The failure of a *disk* drive to read or write data correctly due to a *software* bug, a virus, a power failure, a dirt particle, excessive heat, or physical contact between the read-write head and the *disk* platter.

Display PostScript®
A method developed by *Adobe Systems*, Inc. to display composed pages of type and graphics (including *color*) on a computer *screen* using the same *PostScript file* that will generate the final printed output. Display PostScript offers the greatest accuracy for *soft proofing* files.

display type
A letter, figure or other *character* that is used for headlines, titles and signs. The strict definition for display type is type that has been set larger than 14 pt. Display type is characteristically larger and bolder than text type. Standard text typefaces, such as Times Roman, can be set as display type, although display type often uses special typefaces designed especially for the display function, such as Albertus or Cooper Black.

dither
A technique of interpolation to fill in a gap between two *pixels* with another *pixel*. The value of the new *pixel* is the average value of the two *pixels* on either side of it. The result is a smoother edge with less *jaggies*.

Dmax
(DEE-max) Acronym for *maximum density*.

Dmin
(DEE-min) Acronym for *minimum density*.

Document Exchange Format
See *DXF*.

dongle
a small piece of computer hardware supplied by software companies to prevent unauthorized software duplication. The software will check for a digital serial number on the computer hardware and will not operate if the hardware is not connected to the computer system.

DOS
See *MS-DOS*.

dot
The individual element of a *halftone*. Dot should not be confused with *spot*, the smallest diameter of light that a *scanner* can detect, or an *imagesetter* or *film plotter* can expose—see also *dpi*, *EDG*, *elliptical dot*, *pixel* and *screen ruling*.

dot area
The percentage of an area covered by a *halftone dot* ranging from no *dot* at 0% to a solid ink *density* at 100%. The size of the *dots* is stated in percentage of the area they occupy. A square *dot* at 50% creates a checkerboard pattern.

dot etching
A technique that physically reduces the *dot sizes* on film by emersion in acid, by using photographic overexposure on contact and *dupe* films, or by electronic etching or *airbrushing* on a computer. Dot etching is done to change *hues* in specific areas of the reproduction—see *dry dot etching*.

dot font
A *file* of *dot sizes* that are used to expose the required *dot size* on the output media.

dot fringe

See *soft dot*.

dot gain

The apparent *dot size* increase from the film to the printed reproduction. Dot gain can be simulated on a video monitor by adjusting the white point and *gamma (contrast)*.

Dot gain is the physical enlargement of the *dot* caused by *plate exposure* image spread, by the pressures between the plate blanket and impression cylinder of a press, or by ink spread as it penetrates the paper. The apparent darkening of the *dot* border can add as much as 20% to the dot gain. Since the *dot* gain is greatest where the *dot* circumference is largest, the dot gain profile usually appears as a Volkswagen curve when plotted. Choosing too fine a *screen ruling* will increase the dot gain and cause plugging on the press.

The *dot* diameter expansion is usually uniform in *dots* of different sizes, making the diameter of the *dots* change by the same amount in *highlight*, *middletone* or *shadow dots*. However, the area around the *dot* will increase more when

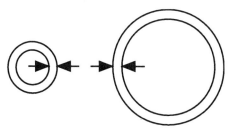

Identical diameter dot gain

there is greater circumference around the *dot*. Therefore, the greatest dot gain occurs in the *middletone*, around the 50% *dot size*. This tends to darken reproductions by printing too much *middletone dot area*. In *process color* printing, dot gain is usually greater in the *unwanted colors* causing a "dirtying" of all *hues*. To compensate for the *middletone* dot gain, the

prepress should reduce the *dot sizes* throughout the *middletones* in all colors so that the *separations* fit the dot gain of the printing process. Some typical dot gains as measured with a *dot area* meter are:

 coated sheetfed *lithography* at 150 *lpi*15% dot gain
 uncoated sheetfed *lithography* at 133 *lpi*..20% dot gain
 coated *web offset* for *SWOP* at 133 *lpi*22% dot gain
 newsprint *web offset* at 100 *lpi*30% dot gain

See also *doubling, fill-in, optical dot gain, physical dot gain* and *slur*.

dot gain compensation
The technique of reducing the printing dot sizes of halftone separation films to compensate for the expected dot gain on press. The reduction is done mostly with the middletone controls as that is where the gain is the greatest.

dot range
The total spread of *dot sizes* from the minimum size to the maximum size for a given film or device.

dot shape
The form of the *halftone dot* that may be intentionally varied from round to elliptical to square. *Halftone dots* are made with specific physical configurations to minimize *dot gain* and *moiré*. The dot shape is varied to minimize the *dot gain* at the point where *dots* join one another. *Elliptical dots* minimize the sudden *dot gain* where corners of *dots* connect; they may connect in their short direction at 40% *dot area* and in their long direction at 60% *dot area*. Round *dots*, often used for newsprint, may not connect until about 70% *dot area*.

Complete Color Glossary

dot size
See *dot area*.

dots per inch
See *dpi*.

doubling
A printing defect of *lithographic* printing caused by a mechanical problem on the press that results in a second set of *dots* printing between the expected or desired set of weaker *dots* in a *halftone* image. The defect appears as *color* changes and a darker than expected reproduction.

downlink
The communication link sending data down from a satellite to an *earth station*.

download
Sending information to another computer. For example, downloaded fonts are sent from a computer to a *laser printer* or high *resolution imagesetter*.

downloadable font
A digital typeface that can be output to a digital output device, such as a *laser printer* or an *imagesetter*. Some *digital fonts* have been rendered only for display on computer *monitors* and are referred to as *screen fonts*.

dpi
Abbreviation for *dots per inch*, a measure of *resolution*. When dpi is discussed by *desktop* publishers, they are actually referring to the number of *spots* per inch that can be input on a *scanner* or output on an *imagesetter*. Dpi does not refer to *halftone dots*. *Halftones* are specified in *lines per inch (lpi)*.

drawing
Desktop publishing software that employs *vector graphics*, as opposed to a *paint program* that uses *bitmap graphics*.

driver
Software that aids the transfer of information between the computer and the peripheral controlled by the driver *software* program. In publishing, the most common are printer drivers.

drop cap
The large capital letter on the first letter of the first word of a paragraph that is aligned at the top with the rest of the type and is typeset at a size, at least, double the paragraph type size. A drop cap is set to drop down through two or more lines of text such that the remaining type must be set around it. Typesetting *software* and *page makeup software* sometimes offer automatic drop cap features.

drop-out highlight
See *specular highlight*.

drum imagesetter
A high *resolution laser* output device that utilizes a revolving drum. The film is mounted on (external drum imagesetter) or in the drum (internal drum imagesetter) for *exposure*, as compared to a roll-fed or *flatbed imagesetter*, where the film is pulled with rollers past a light source.

drum scanner
An optical scanning device for converting an optical image to an electronic image by analyzing the *original copy* mounted on a revolving drum or cylinder. As the drum revolves a *spot* of light illuminates the surface while a photo-detector looks at each *pixel spot* as it passes by. After each row of *pixels* is analyzed, digitized and stored, the optics

move sideways one row and repeat the process until the entire picture *raster* image is stored. A *color scanner* utilizes a *red, green and blue filter* to analyze the *pixels*. Most *high-end* scanners are drum scanners with photomechanical tubes that produce the high *resolution* images. *Flatbed scanners* usually utilize *CCDs* to analyze images, usually at lower *resolutions* than drum scanners.

dry dot etching
A technique that is used to change *halftone dot* sizes in all or specific areas of *color separations* by overexposing positive or negative contact films that were made from the *halftone separation* films. *Dots* already on a film are reduced or enlarged as needed—see *dot etching*.

DS
See *Screen*.

DTP
Abbreviation for *desktop publishing*. However, if *desktop* equipment is used to make masters from which *plates* are made for a printing process, a better term is "*desktop* prepress."

dummy
1. An approximate sample of a final printed piece prepared with a designer's tools.
2. A press signature folded for proper page positioning during the imposition step.

duochrome
See *duotone*.

duotone
A halftone image created by overprinting two different halftone screens of the same image with different tonal

values. Duotones are printed using two black inks or a black and a colored ink. When both inks are colored it is sometimes called a duochrome.

Duotones are created to increase the detail and saturation of the black part of an image, or to create a special effect.

dupe
A second generation original, a reproduction of an *original transparency* made on a *transparency* film for the purpose of changing its size or to make additional copies to supply multiple printing sites.

duplex
1. In data communication, a mode that permits a user to transmit and receive data simultaneously. Half duplex permits the user to either transmit or receive.
2. A *laser* that prints both sides of a sheet simultaneously.

DVI
Abbreviation for Digital Video Interaction, a *file format* developed by Intel to store compressed full-motion video.

dye sublimation printer
A *digital proofing* device that transfers dye images from a carrier sheet to a receiver sheet by placing the two sheets together during or after *exposure*.

dye transfer print
A photographic *color* print that is made by transferring a separate *cyan*, *magenta* and *yellow* image from *separation* matrix paper images onto a receiver paper.

dynamic range
1. The range between the *minimum* and *maximum density* of an *original*, a *proof* or a printed reproduction. Means the same as *density range*.

Complete Color Glossary

2. In an optical imaging device, a measure of the device's sensitivity range.

DXF

Abbreviation for Document Exchange Format, a *file format* that is used for *CAD* images. DXF was created for the AutoCAD program by Autodesk, Inc.

earth station
An on-the-ground satellite dish for transmitting and receiving signals from a satellite traveling above the earth.

EDG
Abbreviation for electronic *dot* generation, the formation of *halftone dots* on film or paper using a series of multiple *exposures* from a light source, usually a *laser*, through multiple *fiber optic* channels in a *raster format* without the use of a contract *screen*.

edge enhancement
A *scanner* process that increases the apparent edge *sharpness* of the reproduction images by intensifying the difference between the light and dark side of the image edge or the point where different colors meet—see *unsharp mask* and *unsharp masking (USM)*.

editability
A data *file* is considered editable if ordinary *software* can be used to reopen it and change its content. *PostScript* output files are not considered editable because there are few software programs available that can rework the *PostScript* code. Data exchange standards such as *PIL* have been proposed to increase the editability of *PostScript* files.

editorial changes
Modifications requested by the customer to change certain elements within the *original* image during the *separation* process. See *AA*.

EGA
Abbreviation for Extended Graphics Adapter, a medium *resolution* video card, developed after *CGA*, for IBM-style computers. EGA displays up to 16 colors with 640 *pixels* horizontally and 350 *pixels* vertically; it is not for professional publishing use.

EIP
An abbreviation, coined by Dunn Technology, for electronic integrated processes for print. The phrase describes all prepress production units from design to film or *plate* output that are linked together so that data flows in all directions, eliminating the extra steps of re-inputting images.

electronic camera
A camera that captures the image as *analog data* and records the information as either *analog* or *digital data*. Later the image can be displayed on a *video monitor* as a single frame that is shown over and over again.

electronic dot generation
See *EDG*.

electronic gray scale
A narrow strip of exposed *density* or *halftone dot* steps made on paper or film from values stored in a *color scanner's* calibration *software* or memory. Electronic gray scales are used for calibrating the *scanner's* output.

electronic publishing system
A configuration of hardware and *software* that is used for digital page composition. Electronic publishing system is the broad category that includes *desktop publishing, midrange* and *high-end systems*. An electronic publishing system may or may not use *standard platform* computers, *off-the-shelf software*, or a *device-independent page description language*.

electronic still photography
Photography that is either analog or digital, or both, but where the image is in an electronic format at some stage in the picture handling process.

electrophotography
An image transfer *system* that is used in copiers in which images are produced using electrostatic forces.

ellipsoid
An oval image shape similar to an ellipse.

elliptical dot
An elongated, or oval, *halftone dot* that is used in the *middletone* and *vignette* areas to minimize the midtone jump in *dot gain* at the point where *dots* are large enough to connect.

em
A measure of space that is equal to the square of the type body—the larger the type size the larger the em space. An em space is sometimes specified as the amount of the indent of the first line of type in a paragraph. Em is so called because in early *fonts*, the letter M was usually cast on a square body, such as 10 point high and 10 points wide—see also *en*.

em dash
A dash, one *em* long, that is used to separate parenthetical phrases within a sentence or to indicate missing words.

Emerald RIP
The first *RISC*-based *PostScript raster image processor*, released by *Adobe* in 1990.

emulsion
The light-sensitive coating, made from photo-sensitive materials, that is used on photographic films or *printing plates*.

emulsion side
The dull-appearing surface of a photographic film on which the *emulsion* has been applied; the side on which the image is developed or scribed. The emulsion side of the film should be down against the plate coating during exposure so that image sizes are not unintentionally spread and made fatter.

en
A measure of space, equal to half of an *em* space in the same typeface.

Encapsulated PostScript
See *EPS*.

encryption
Set in code. *PostScript Type 1 fonts* have special "hints" encrypted into their digital descriptions. These hints are used to improve the appearance of the type when it is set at small point sizes.

Complete Color Glossary

en dash
A dash used to indicate a range, as in "There are 1000–1100 terms defined in this glossary." An en dash is longer than a hyphen and half the length of an *em dash*.

environment
Special conditions needed for the operation of electronic *systems*. The room may need to be air-conditioned to remove the heat generated by the *system* or the people. The *disk* drives may need to be placed in a separate *clean room* where the dust particles are removed from the air and the enclosure is under positive pressure to keep dust out. Near the *system color* video display, a low light level (approximately two foot candles with no glare) is needed for proper viewing. Some *systems* can operate in an office environment that does not have special air-conditioning or low light levels.

EPS
Abbreviation for Encapsulated PostScript, a graphic *file format* developed by Adobe Systems. EPS is used for *PostScript* graphic *files* that are to be incorporated into larger *PostScript* documents. The EPS format offers flexibility because EPS *files* include both a *low resolution viewfile* and the high *resolution PostScript* image description. The *Macintosh* version of EPS differs from the *PC* version in that the *viewfile* on the *PC* is in *TIFF* or *Microsoft Windows* metafile format, while on the *Macintosh* it is in *PICT* format.

EPS5
Refers to a file in *DCS* format.

EPSF
Abbreviation for Encapsulated PostScript format. EPSF has the same meaning as *Encapsulated PostScript (EPS)*.

erasable optical disc
See *rewritable optical disc*.

error diffusion
The slight change of adjoining *pixels* to average *pixel* values. This smooths an area and eliminates the graininess of a digital image.

Ethernet
Originally developed by Xerox, a widely-used high-speed digital communication *network* that uses *coaxial cables* to connect computers. Ethernet can connect up to 1,024 computers and *workstations* within each main branch and can transmit at 10 megabits/second.

exception dictionary
In page composition, a resident list of words that cannot be hyphenated correctly using the available hyphenation *algorithm*. A user defined exception dictionary contains words that a user wants to hyphenate differently than the hyphen points suggested by the *algorithm*.

expanded
See *extended*.

expansion board
A plug-in circuit board used to expand the functions of a computer.

expansion bus
Electronic plugs or connectors inside the computer where *expansion boards* can be added.

expert system
a computer-controlled *system* that executes functions normally requiring the decision-making ability of someone with a particular skill.

export
To output data in a *format* that can be read by another software *application*.

exposure
The amount and duration of illumination striking a sensitized material, such as film, paper or *plate*, or an electronic sensor, such as a *CCD*.

exposure level
The quantity of light that is allowed to act on a sensitized material, such as film, paper or *plate*, or an electronic sensor, such as a *CCD*.

extended
In typesetting, *fonts* that have broadened *character* widths, but no increase in height. Extended is the opposite of *compressed*. Sometimes referred to as expanded.

extension
A generic name for modular *software* programs that work as part of a larger program, extending and expanding its function for a particular task. The extension functions as if it were part of the original program. Other names for extensions are *additions,* annexes and plug-ins.

external drum imagesetter
See *drum imagesetter*.

facsimile
A reproduction of an image that is identical to the *original* in every detail including any unwanted blemishes.

facsimile transmission
The use of a communication *network* (satellite, microwave, *fiber optics* or copper wire) to send data for the reproduction of an image that is identical in every detail to the *original*. Usually called fax.

fade-off tone
In *gravure*, a *halftone dot* that is so small that when printed it disappears.

fan book
In a *color matching system*, a set of small *color* charts, similar to a deck of cards that have been fastened together with a clasp in one corner. The user can spread the charts and match a sample to the correct *color* patch.

fatties and skinnies
A fatty is a spread, and a skinny is a choke—see *spreads and chokes*.

FDDI

Abbreviation for Fiber Distributed Data Interface, a communication link between two independent devices that uses a *fiber optic* token ring to pass data at 100 megabits per second.

fiber optics

Multiple strands of fiberglass enclosed or bundled to form a cable that transmits light pulses, representing *digital data*. Sometimes called light pipes, fiber optic cables transmit at a much higher data capacity than copper wire. The *networking* and communication industries are moving towards fiber optic cabling as the next generation standard.

file

A group of related pieces of information (comprising text, graphics, page instructions, look-up tables, and/or picture information) identified with a unique name. Files are stored on magnetic *disks*, magnetic tapes or *optical discs*.

file format

See *format*.

file management

The process of maintaining *file* locations, sizes, updates, transfers, etc. for the purpose of locating, updating and billing.

file server

In a computer *network*, a file server is a computer that handles the *network* control and *file management* function.

fill

The process of inserting a specified *tint* or pattern within an enclosed geometric shape.

fill-in
One of several types of *dot gain* caused by reasons other than *doubling* or *slur*.

film plotter
In *color systems*, a stand-alone device that writes across film using a *laser* or *LED* to expose type, line or *halftone* images in a sequential manner. Film plotters are different from *imagesetters* and *film recorders* in that they have no *raster image processor* directly connected to them.

film processor
A machine used to develop photographic film which has been exposed in an *imagesetter*, *film plotter* or *film recorder*.

film recorder
1. By definition, the same as an *imagesetter*, but in practice, the term usually refers to higher quality *imagesetters* that are used primarily for recording *color separation* film.
2. A device that is used to record an image file as a 35mm or 4" x 5" *color transparency*, which is usually used for *second generation originals* or presentation graphics.

filter
A device that can separate one *color* from another by allowing only portions of the *visible spectrum* to pass through—see *Wratten gelatin filter* and *screening filter*.

final proof
See *contract proof*.

finder
In the *Macintosh operating system*, the place where a user can visually locate files and *applications*—see also *desktop*.

fine data file
See *high resolution file*.

fingerprinting
A method of testing a printing press to determine its exact printing characteristics, such as its *dot gain*, ink *density* and *trapping*, for the purpose of customizing *color separations* for those printing conditions.

FIPP
The European specifications for *offset printing* on coated paper; the International Federation of Publishers Press developed these guidelines for *color proofing* and printing of periodicals. *SWOP* are the equivalent U.S. specifications; *SNAP* are the U.S. specifications for printing on newsprint.

five-file EPS
Refers to a file in *DCS* format.

flat
1. A collection of properly imposed *negatives* or *positives* attached to a goldenrod or film carrier sheet from which the *plate* will be exposed.
2. Properly imposed pages that will result in a signature.
3. A term that is used to describe a photograph that is lacking in *contrast*.

flatbed
An adjective describing an optical input device or output device that utilizes a flat plane for the image input or recording rather than a revolving cylinder. There are both *flatbed scanners* and *flatbed imagesetters*.

flatbed imagesetter

An *imagesetter* that feeds the paper or film from a roll and holds it flat while it moves past the exposing light. Sometimes called roll-fed imagesetter or capstan imagesetters, because the paper feed mechanism uses capstan rollers. The alternative is a *drum imagesetter*.

flatbed proof

A *color proof* that is made using ink on paper and a *flatbed* printing press to simulate the appearance of the reproduction before it is printed on a production press. Paper is fed by hand, one sheet at a time, into the press.

flatbed scanner

A *peripheral* digital device that uses a flat glass surface on which the *original* is mounted and scanned. The light moves across the surface to create a digitized black-and-white or *color separation file* of any two-dimensional image, such as a *transparency*, photograph or artwork. Most flatbed scanners use *CCD* sensors—see also *drum scanner*.

flat tint

A printed area containing *halftone dots* that are all the same size, as opposed to a *halftone* or a *vignette*. Flat tints are usually just called tints.

flexography

A printing process that uses a raised surface, flexible rubber or photopolymer *printing plate* mounted on a rotary drum and thin, fast-drying inks to print on almost any material.

flop

To rotate an image so that the left side is on the right side, and the right side is on the left side. Flop is often confused with *reverse*, which describes the process of creating a *negative* image.

flush left

A block of text set so that each line begins at the same left hand point, but ends at a different right hand margin — in contrast to *justified text*.

flush right

The type in a block of text aligns on the right side but not on the left side—also called *ragged* left.

Focoltone®

A *color* matching product that utilizes an array of printed *color* swatches. Focoltone is used to specify *process colors*.

focus

The act of adjusting the elements of an optical *system* to capture the sharpest image with the most detail.

folder

A *file* and program organization method that is used with the *Macintosh operating system*. Individual files and programs are usually stored within folders, making it easier to keep them organized on a *disk*. A *Macintosh* folder displayed on the *monitor* has the shape of a miniature paper file folder.

folio

In typesetting, the typeset page number. Right hand pages always contain the odd numbered folios.

font

A group of 26 capital and 26 lower case *characters* plus punctuation marks, asterisk and daggers, fractions, accent letters, and special *characters*, all of a specific type style, such as *roman*, *italic* or bold. Not all special *characters* are available in all fonts—see also *printer fonts, screen fonts, Type 1 fonts* and *Type 3 fonts*.

Font/DA Mover
An *application* included with the *Macintosh operating system software* that is used to load *fonts* and *desk accessories* into the *Macintosh* computer.

font downloader
A *software utility* that is used to send *digital font* information from a computer to an output device.

foot candle
A standard unit of illumination, the light given off by one lit candle measured at a distance of one foot. For example, the illumination level in a standard viewing booth is 200 foot candles.

format
1. An exact geometric arrangement or organization of *file* data or computer command codes.
2. (verb) To prepare a magnetic floppy *disk* so that data can be stored on it.

for position only (FPO)
On a *mechanical*, a designation that an image has been added only to indicate its position within the layout. The artwork or *transparency* to be reproduced in the same position is sent separately.

four-color process
The method of printing *process color* using *separations* and the four colored inks, *cyan, magenta, yellow* and *black*.

four-stop photography or 4-stop photography
See *measured photography*.

FPO
Abbreviation for *for position only*.

frame
In some page layout *software*, a rectangular area defined by the user and then filled with text and/or graphics. A frame is used in grid-oriented *page makeup software* such as *QuarkXPress* and *Ventura Publisher*.

frame buffer
A *video monitor* card that is used to store a single frame from a video image.

frame grabbing
The act of electronically capturing a single picture element, or frame, from a video tape or an *optical disc* for the purpose of viewing it, manipulating it or outputting it for reproduction with ink on paper or on photographic material.

FreeHand
A *software* program published by Aldus that is used on the *Macintosh* computer for *vector drawing* and illustration.

frequency
The number of times something happens over a given time or space, such as *dots per inch*, *lines per inch* or millimeters, and cycles per seconds.

frequency histogram
A graphical analysis or organization of data in the form of a bar graph or chart that describes how many times each occurrence of a variable took place for a given sampling. Some *color scanners* create an electronic frequency histogram to automatically adjust the *midtone* placement for each *original*.

The histogram dialog box in Adobe Photoshop

full bleed

A *bleed* extending into all four margins.

full resolution video display

A computer display of every *pixel* in a given data *file* area. Because of the large amount of data, only a small portion of the total image can be displayed at one time. This differs from a *coarse data file* or *viewfile* display that is a low *resolution* display and only a sampling of the *pixels* of the entire stored image. Full resolution video display is usually used for *retouching*.

full-scale black

A *black printer separation* that contains picture elements ranging from the whitest *highlight* to the darkest *shadow*, and prints *dots* in every part of the picture. Full-scale black, also called full-range black, differs from a *skeleton black,* or *half-scale black*, which only prints *dots* in the darker areas of a reproduction.

fuzzy fonts

Gray *pixel* values that are used to smooth edges of type by filling in the spaces between dense *pixels* on the edge of *jaggies*—a form of *anti-aliasing*.

GAA
Abbreviation for the Gravure Association of America, an organization dedicated to the advancement and dissemination of information for the *gravure* industry.

gain
See *dot gain*.

galleys
A continuous roll of typeset text that is used for proofreading and is not yet assembled into pages. Now that most typesetting *systems* are able to compose complete pages, galleys in the true form are becoming rare. However, sheets of text output from a device, such as a *laser printer*, used for proofreading and not yet assembled into final pages are often called galley sheets or galleys.

gamma
The computed number that denotes *contrast*, represented by the Greek letter γ—see *contrast*.

gamma correction
A modification of the *tone curves* to change the *contrast* of a reproduction. Gamma correction does what some people misinterpret as *color correction* because it changes *middletone*

and "cleans up" the picture. Gamma correction will increase or decrease all the middletones. However, since the unwanted *color* is in the *middletones*, that *color* is changed the most. For example, consider a reproduced apple that looks dark and uncolorful. By reducing the *middletones*, *cyan*, which is printing at 10 to 40 percent in the reproduced apple *color*, will be reduced the most. Now, the reproduced apple *color* will appears cleaner and brighter. This will not only improve the apple *color*, everything in the reproduction will appear more appealing. Also called *tone correction*. See also *contrast*.

gamma curve
See *contrast*.

gamut
Every *color* combination that it is possible to produce with a given set of colorants on a given device or *system*.

gamut compression
The process of squeezing the *color space* represented in an image to one that can be reproduced in a second image generation, such as ink on paper, a *direct digital color proof*, etc.

gamut mapping
The process of aligning the *color space* of one device with that of another, accomplished with *algorithms* or *look-up tables*.

GATF
Abbreviation for the Graphic Arts Technical Foundation, an organization located in Pittsburgh, PA, dedicated to improving quality in the graphic arts through testing and education. GATF distributes a range of color *quality control* devices and publications.

GATF Color Circle

A circular plotting paper upon which the *hue* and gray of colors are plotted using readings taken with a *densitometer*. The GATF Color Circle is usually used for analyzing ink sets.

GATF Color Hexagon

A hexagon shaped plotting paper upon which the *hue* and strength of colors are plotted using readings taken with a *densitometer*. The GATF Color Hexagon is usually used to analyze the effects of printing process inks and their *overprint colors, red, green and blue*.

GATF Color Measurement System

A method of measuring ink *density*. The *hue error* and *grayness* of a colored ink are computed using the numeric results of *red, green* and *blue filter densitometer* readings. This system was invented by Frank Preucil and is sometimes called the Preucil Color Analysis System.

GATF Color Triangle

A triangular shaped plotting paper upon which the *hue* and gray of colors can be plotted using readings taken with a *densitometer*. The GATF Color Triangle is usually used for the purpose of determining *masking* for *hue error* correction.

GATF/REHM Light Indicator

A device that is used to verify standard lighting conditions for viewing *proofs*.

GATF Standard Offset Color Bar

See *Standard Offset Color Bar, GATF*.

GCA

Abbreviation for Graphic Communications Association, a subgroup of the Printing Industries of America. GCA is an

organization of advertising people, *color* separators, publishers and printers dedicated to improving *color* publication printing.

GCA T-Ref
See *T-Ref*.

GCA/GATF Proof Comparator
A set of four-*color* film test targets that are used to determine if a production *proof* is made correctly. These test targets are included each time a *proof* is made. The completed *proof* can be compared to a sample *proof* of the same *color* test target made under very exact, controlled standard conditions.

GCR
Abbreviation for gray component replacement, the technique of reducing the *cyan, magenta,* or *yellow dot* sizes that produce the gray component, or darkening effect, in a *color* without changing the *hue* of the *color*. The *black dot sizes* are increased to replace the gray component that has been reduced in the *process colors*. If 100 percent GCR were used, every *color* area in the reproduction might contain *dots* of only *black* and two of the three *process color* inks. Commonly used percentages are 50% to 75% GCR. The goal of GCR is more consistent *color*, increased detail in the shadows, shorter press *makeready*, and possible ink savings.

GCR Guide
A printed poster of information that describes many aspects of gray component replacement *(GCR)*. Available from *GCA*.

GEM
A graphic *windowing* system that is used with *MS-DOS*, developed by Digital Research. *Ventura Publisher* is the most popular *desktop publishing* program that can operate with

GEM. However, *Ventura Publisher* is now also available for the more popular *Microsoft Windows*.

GEM/IMG
See *IMG*.

geostationary satellite
A communication satellite placed in a fixed location in space. It travels above the earth at a higher speed than the earth rotates so that it seems to remain in a fixed position relative to earth.

GIF
Abbreviation for Graphics Interchange Format, a standard developed by CompuServe for *bitmap graphics* of up to 256 colors.

gigabyte
One thousand *megabytes* or one billion *bytes*.

gigahertz
A unit of *frequency* equal to one billion cycles per second.

GKS
Abbreviation for Graphical Kernel System, an *ISO* standard *file format* for *vector*-based graphics.

global correction
A *color correction* technique that is applied to an entire image area. While global correction makes the same correction everywhere in the image, *local color correction* is only applied to a given area of the image that is localized through a mask.

glow lamp
A crater discharge lamp capable of exposing films with variable *brightness* up to its maximum output. Its instant variability in intensity is dependent on the analog voltage applied to it. Glow lamps were used on early *high-end color* drum scanners.

good-enough color
A name given to the *process color* quality that is often attributed to *desktop systems* and *midrange systems*. The *color* quality may be sufficient to meet the customer's need, but may not be equal to the *color* quality produced on a *high-end*, graphic arts *system*.

GPIB
Abbreviation for general purpose interface bus, an industry-standard interface used to connect *peripheral* devices, such as *color scanners*, to *desktop* computers.

gradation
See *contrast*.

graded tint
See *degradé*.

graphic accelerator
Microprocessors used to speed the display of images on a computer *monitor*.

Graphic Arts Technical Foundation
See *GATF*.

Graphic Communications Association
See *GCA*.

Graphical User Interface
See *GUI*.

gravure
An intaglio printing process that works with a cylinder in which the image is engraved below the surface. The ink is transferred when the paper is pressed in contact with the cylinder. Gravure is used for very long print runs. It can print on most any type of *substrate*.

Gravure Association of America
See *GAA*.

gray balance
Combinations of *cyan, magenta and yellow* colorants that appear similar to shades of gray. It is important to maintain the neutrality of the grays throughout the *proofing* and printing process.

gray component replacement (GCR)
See *GCR*.

gray level
With image input and processing, a given amount or value related to an *original* image as seen through a *color separation filter*. Older *scanners* only stored 64 gray levels; today, it is common to store 256 gray levels. Although 256 levels are considered more than sufficient to render smooth transitions, some *systems* offer up to 1,024 gray levels.

gray levels
With image output, the number of tonal differentiations that can be recorded on film or paper. The number of gray levels possible depends upon the output *resolution* and the *halftone screen ruling*.

grayness

The amount of gray content of a *color* is determined by measuring the *color* with a *densitometer* having three, *RGB, wideband filters*. To calculate grayness so that it can be plotted on the *GATF Color Triangle*, use the following equation:

$$\text{grayness} = \frac{L}{H}$$

Where L is the lowest of the three densitometer readings of a color, and H is the highest of the three readings.

gray scale

A narrow strip of paper containing an orderly progression in definite steps or patches of gray densities or printed *halftone* steps ranging in *dot sizes* from zero to 100%. A gray scale is used to analyze and optimize the *contrast* of black-and-white and colored reproductions. The gray scale may be reflection-type made on photographic paper, on a *color proof*, or printed on paper. On film, with definite steps of either *continuous tone* or *halftone dots*, it is called a *step tablet*. On film without definite steps, it is a *continuous wedge*. On film with *dots* and definite steps, it is a *halftone scale*. On a computer *monitor*, shades of gray are created by varying the intensity of the *screen's pixels*, rather than by using a combination of only black-and-white *pixels* to produce *shading*. Printed, it is produced as a narrow strip of paper, usually in the trim area of a job, and used for analyzing printing characteristics.

gray stabilization

The capability of maintaining *neutral gray balance* during *color* reproduction. The use of *GCR* helps to stabilize neutrals. Gray stabilization was introduced by *System Brunner* to explain the importance of maintaining the *neutral grays*.

green

Describes the *color* of grass and lettuce.
1. A *primary color* of light.
2. The portion of the *color* spectrum that is aligned between *blue* and *yellow*.
3. In printing, a secondary *color* resulting from *overprinting dots* of *cyan* and *yellow process color* inks—see *additive color primaries,* and *additive color theory*.

groupware

Software programs that can be used at the same time over a *network* by different people working on the same *file*.

GUI

(GOO-ey) Abbreviation for graphical user interface, a reference to computer *operating system*s that employ graphics, such as the *Macintosh operating system* or Microsoft *Windows*.

h & j
Abbreviation for hyphenation and justification, a typesetting term that refers to the balanced process whereby text is set to a given line length so that it is aligned on both left and right. To accomplish the desired effect, automatically, hyphens are inserted in a body of text, while adjustments are made to letterspace and word space.

half-scale black
See *skeleton black*.

halftone
A *negative* or *positive* image made by photographing an image through a *screen* so that the detail of the image is reproduced with *dots*. The reproduction simulates the different *tones* of the *original* by transforming them into *dots* of varying sizes arranged in a grid pattern that has a given *frequency*. For example, a 150 *lines per inch* (54 lines per centimeter) halftone would contain 150 rows and 150 columns of *dots* (22,500 in a square inch) that could vary in size from zero percent to 100 percent—also called screened negative or screened positive. Halftones can also be generated electronically from *digital data*—see *EDG*.

halftone cell
In digital halftoning, a *halftone dot* is made up of printer *dots* (from a *laser printer* or *imagesetter*) arranged within a halftone cell. See also *supercell*.

halftone scale
See *gray scale*.

halftone screening algorithm
See *screen algorithms*.

handshake
1. The first two-way signal exchange between two computers that determines whether or not they are connected, compatible and ready to communicate.
2. (HandShake™) A communication *protocol* that was established by *Scitex* as a standard method to exchange data between *color* prepress *systems* and *peripherals*.

hanging indent
All the lines of type in a paragraph indented except the first line.

hanging punctuation
Punctuation set outside the margins of justified text. Because of the white space that surrounds punctuation, some designers consider this arrangement to be aesthetically preferable to setting the punctuation within the line length.

hard disk
A mass storage device for computers, usually installed inside the computer chassis, or sometimes kept in a separate case beside it. Usually, a hard disk contains between 20 and 1200 *megabytes* of storage capacity, although larger sizes are now available.

hard dot

A *halftone dot* on film that has well-defined edges with no fringe. Hard *dots* are exposed with a *laser*, or made by contact from another film. *Dots* made with a contact *screen* have soft edges that can cause *dot sizes* to vary during platemaking—see *soft dot*.

hard proof

A *color proof* made on a *substrate* from production films or on a *substrate* directly from the stored *pixel* data. When made directly from stored data, the hard proof is usually referred to as a *DDCP* (direct digital color proof), whereas a video monitor *proof* is called a *soft proof*.

HDTV

Abbreviation for High-Definition Television, a standard developed in Japan, that raises television *screen resolution* from 525 lines to 1,024 or more.

head crash

A computer failure that occurs when the read-write head of a magnetic *hard disk* touches the *disk* usually rendering information on the *disk* unreadable.

helium neon laser

A *red laser exposure* device, with a peak output of 632.8 *nanometers,* that is used for exposing *red*-sensitive photographic films, paper, *plates* or cylinders. Helium neon lasers are claimed to be more stable and less expensive to purchase and operate than *blue argon laser*s.

Hell

Dr.-ing. Rudolf Hell GmbH, founded in 1929 in Berlin-Badelsberg, Germany, one of the pioneering firms in *color scanners*, digital typesetters and *CEPS*. Hell is now part of Linotype-Hell GmbH, headquartered in Eschborn, Germany.

Hell angles

Dr.-ing. Rudolf Hell GmbH (now Linotype-Hell) holds several patents on screen angles. "Hell angles" generally refers to its digital *halftone irrational screening* algorithms. These algorithms are usually considered among the highest quality available and are licensed by other *CEPS* vendors.

Hell Users Group

See *Linotype-Hell Users Group*.

help files

Digital files, containing instructions for *software* use, that are accessed from within a *software* program. Help files are used to supplement the instructions contained in program manuals.

HeNe

(HEE-nee) Abbreviation for *helium neon laser*.

hertz

A unit of *frequency* equal to one cycle per second of electronic or optic signals.

high-end

Describes devices and *systems* that are relatively high-priced and high-quality; the traditional equipment of the *color* electronic prepress industry. In the graphic arts, a *CEPS*, rather than a *midrange* or *desktop system*, is described as a high-end *system*.

high-key transparency

A very light, possibly overexposed, *transparency* that has most of the important detail in the *highlight* area and has very few *shadow* areas. *Contrast* (*gradation*) must be adjusted

differently for high-key transparencies than it is for normal or *low-key transparencies*.

highlight

The most white portion of the *original* or reproduction that has no *color cast*. In the reproduction, it may print the smallest printing *dot*, the *diffuse highlight*, or print no *dot*, the *specular highlight*.

high resolution file

In a *CEPS*, the stored high resolution information that contains all the detail necessary to produce an accurately printed reproduction. A high resolution file is commonly input at a *sampling rate* of at least four *pixels* for each *dot* to be reproduced at the final size. The corresponding *low resolution file* or *viewfile* is created at the resolution of the video monitor. Sometimes called high res file.

hints

See *encryption*.

histogram

See *frequency histogram*.

HLS

Abbreviation for *hue, lightness* and *saturation*. Some *color system software* uses these values for computational purposes.

HPGL

Abbreviation for Hewlett-Packard Graphics Language, a *CAD file format* that is used for pen plotters.

HQS®

Abbreviation for High Quality Screening, a *rational screen angle* algorithm used to enhance PostScript color output.

HQS is a patented Linotype-Hell product. See also *Balanced Screening* and *IntelliDot*.

HSV
Abbreviation for *hue, saturation* and *value*, means the same as HLS.

hue
The attribute of *color* that designates its dominant wavelength and distinguishes it from other colors. *Red* is a different hue than *green*. While bright *red* and dark *red* may have a different *brightness* or *lightness*, they may be the same hue.

hue angle
The angle of the dominant wavelength of any *hue* on the *CIE chromaticity diagram*.

hue error
The amount of contamination in a *process color* pigment or ink that alters its appearance from that of a perfect *process color*. For example, because of *yellow* contamination, most *magenta* inks appear more *red* than a pure *magenta* ink, which is purplish red. All *color separation software* attempts to *color* correct for this error by reducing the *dot sizes* of the *unwanted colors*.

To analyze the hue error of an ink, you take three ink measurements with a *wideband densitometer* using the *red filter*, the *green filter* and the *blue filter*. The equation for calculating hue error is expressed as:

$$\text{hue error percent} = \frac{M - L}{H - L} \times 100$$

Where H is high *density*, M is middle *density* and L is low *density*.

Huffman encoding
A *lossless data compression algorithm*.

Hunter L,a,b Color Solid
A three-dimensional *color model* that displays colors represented by L for *lightness*, ±a for redness-greenness and ±b for yellowness-blueness.

hyphenation zone
When text is typeset *ragged* right, the hyphenation zone sets the area within which words can be hyphenated, thereby controlling the number of hyphens that will appear.

IBM

Abbreviation for International Business Machines Corporation, the Armonk, N.Y.-based manufacturer of the standard-setting IBM PS/2 series of personal computers.

IBM-compatible computer

A computer, manufactured by a company other than *IBM*, that functions identically to the equivalent computer model manufactured by *IBM*. Also called a *PC clone*.

icons

In a graphical *operating system,* such as the *Macintosh operating system* or *Windows*, small pictures that represent *applications*, files and parts of the *operating system* such as fonts and utilities.

IFEN

Abbreviation for intercompany file exchange *network*, a method of interconnecting *peripherals*.

IGES

(EYE-jess) Abbreviation for Initial Graphics Exchange Specification, an *ANSI* graphic standard for *CAD systems*.

Illustrator

A *software* program that is used for *vector drawing* and illustration. Illustrator is published by *Adobe Systems*. There are versions for *Macintosh, IBM-compatible computers* and *NeXT* computers.

image management

The process of *tracking*, recording and finding images on an electronic *color system*.

image processing

The computation and manipulation of data from a picture in order to change its characteristics.

image retouching

See *retouching*.

imagesetter

A high *resolution laser* output device, that writes *bitmap* data onto photosensitive paper or film. The *bitmap* is generated by a *RIP*. Usually, typesetters connected to *desktop publishing workstations* are now called imagesetters because they can record halftones and line images as well as type. There are two main types of imagesetters—*flatbed* and *drum*.

IMG

A *bitmap file format* supported by *applications* running under the *GEM windowing* system, such as *Ventura Publisher*.

import

Bringing data from one *file* into another. For example, a graphic in *EPS* or *TIFF format* can be imported into an *Aldus PageMaker* or a *QuarkXPress file*.

imposition
The correct positioning of pages on a press sheet so that when the press sheet is folded to form a *signature*, the pages are in the correct numerical sequence.

inches to metric conversion
To convert from inches to a *metric* measure, multiply the inches measurement by 2.54 to calculate the length in centimeters and by 25.4 to calculate the length in millimeters.

incident light
The light illuminating a surface from all directions.

inferior characters
Type set below a line in a size generally about 20% smaller than the other text. Also called subscripts. For example, H_2O.

information conversion unit
A device that converts the text, graphic and picture data *syntax*, *format* and *protocols* from one *system* or device to another.

INIT
(IN-it) Abbreviation for INITial, a small *utility* program that loads automatically upon starting up a *Macintosh* computer. See also *cdev*.

ink jet
A method of printing images using jets that squirt miniscule drops of ink onto a variety of surfaces. Images can be produced with single colors. For example, a subscriber's name can be inserted into a magazine, or a color image can be created by using *process colors*.

in-line
Describes components of a *system* arranged in a logical production sequence. For example, an in-line film processor can be connected to an *imagesetter* so that the film is output directly from the *imagesetter* to the processor without operator intervention.

in-line problem
An imbalance difficulty that occurs when the page printing above another in the direction of travel on a printing press requires a different ink feed. Example: the top page needs more *magenta*, while the page below needs less *magenta*. It is impossible to correct this situation on press; the *halftone* images must be altered.

input scanner
An electronic device that scans *original copy* and converts the image into *pixels*. It may use either a revolving drum, *flatbed* or a moving *spot* of light to image onto a *photodiode array*, *CCD* or *PMT*.

IntelliDot
A high-quality *halftone screening* method developed by Optronics. A second version is referred to as IntelliDot II. See also *Balanced Screening* and *HQS*.

interactive
A device or *software* program that varies its course of action as a result of continuing input from the user.

intercompany file exchange network
See *IFEN*.

interface
1. The point of connection and communication between two independent devices.
2. An intermediate device, sometimes referred to as a *black box*, that is used to connect one device to another when the devices have different connectors, data streams, formats or *protocols*.
3. A user interface is the characteristics of the interaction between a computer *system* and a user, sometimes called the human/computer interface.

internal drum plotter
A device for exposing film, paper or *printing plates*. The sensitized material is placed inside the cylinder circumference as a beam of light revolves around the inside of the cylinder and exposes the material. The light moves instead of the cylinder. Also called an internal drum film recorder or internal drum imagesetter. See also *drum imagesetter*.

International Prepress Association
See *IPA*.

I/O
Abbreviation for input/output, usually in reference to a computer circuit board or *port*.

IPA
Abbreviation for the International Prepress Association, a non-profit professional trade association comprised primarily of *color* separators.

IPA Standard Color References
Printed samples of *SWOP inks* used for controlling publication *proofing* and printing. The Hi-Lo Reference illustrates the high and the low *density* for each ink. The Single Level Color Reference is printed at the optimal standard *density*.

irrational screen angles

Screen angles whose tangent is an irrational number. (In trigonometry a tangent is computed as side opposite over side adjacent.) Irrational numbers cannot be expressed exactly; they must be rounded off. *PostScript* has difficulty calculating irrational screen angles, and uses instead a rational screen angle method. Traditional high-end color systems use an irrational screen angling system licensed from Linotype-Hell. See also *rational screen angles*.

ISO

Abbreviation for International Standards Organization, the international standard-setting organization, of which *ANSI* is a member.

ISO/TC 130 (Graphic Technology)

The International Standards Organization committee charged with the responsibility for graphic arts standards.

IT8

See *IT8/WG11 committee*.

IT8/WG11 committee

A group of people striving to pursue *color* communication and control specifications focusing on standards for *RGB*, *CMYK*, *color* transforms, scanning targets and multivendor *system* calibration. This working group is under the IT8/SC1 technical subcommittee of the *ANSI* IT8 committee—see *ANSI*.

italic

A type style in which *characters* slope to the right. Italic is used for emphasis or to indicate a name of a book or other work.

jaggies
The ragged edge of an image that is produced when a diagonal or circular line is scanned into a *system*, and either displayed as *pixels* on a *monitor* or output on an *imagesetter*. Jaggies are caused by a lack of *resolution*. Sometimes called "stair steps."

job tracking
In print production, the act of recording the whereabouts of all components of each job and the production time used for each function—see also *image management*.

Jones Diagram
See *tone reproduction*.

joy stick
A lever that is movable in a 360° arc and used to move images on a *video monitor*—see also *mouse*, *track ball* and *puck*.

JPEG
Abbreviation for Joint Photographic Experts Group, an *ISO* group that has established a standard for the compression of *bitmapped* scanned and rendered *color* images. See also *MPEG*.

jukebox
A device that will store and replay many *optical discs* or data tapes.

justification
The typographic process of evenly aligning both the left and right hand margins of a section of text.

justified text
Lines of set type that align on both their left and right hand sides. The alternatives to justified text are ragged right, ragged left and centered.

K
1. Abbreviation for kilo, which is 1000 units.
2. Abbreviation for kilobyte, a measure of data quantity, roughly 1000 *bytes*, which in fact is 1024 bytes or 2^{10}.
3. Abbreviation for *Kelvin*, which is also a unit of measurement of *color temperature*.

Kanji
The script used for writing Japanese-language text. Kanji contains about 5,000 different *characters*.

kbs
Abbreviation for kilobytes per second (1024 *bytes* per second) that is used as a unit of measurement of data transfer rates.

Kelvin
1. The scale of absolute temperature in which the zero is approximately -273.1°C.
2. A unit of measurement in printing that is used to describe the *color* of a light source, such as 5000K *standard viewing conditions*. *Kelvin* is abbreviated as K.

kerning

The processing of reducing the amount of space between two or more letters in order to balance the appearance of white space. Certain letters because of their shapes appear to be too widely spaced. In *desktop publishing*, *tracking* is reducing the amount of space between words and letters in a line or block of text.

kerning pairs

In typesetting certain pairs of letters, by nature of their design, require *kerning* to improve their typeset appearance. Most digital typefaces have a series of predefined kerning pairs, such as A and W. The *system* user can make adjustments to the preset amount of space for a specific kerning pair.

A kerning pair that has been kerned

A kerning pair that hasn't been kerned

key

Another name for *black printer*. When *letterpress* was the popular printing method, *black* was printed first. The other colors were then *registered* visually to the *black* image, which was considered the key *color*. The "K" in *CYMK* stands for key.

keyline

1. An outline drawn on a *mechanical* (manually or digitally) that indicates a solid area or an area where artwork is to be inserted.
2. Keyline is sometimes used as a synonym for *mechanical*.

kilobit
Roughly 1000 *bits*, which actually is 1024 *bits*.

knockout
In *desktop* graphic *software*, an overlapping image area will often prevent the underlying image from printing, creating a knockout. White type is often created by "knocking out" an image in a specific area so that the color of the paper shows through.

knockout mask
A *mask* created to prevent an area of an image from recording. When one image is layed over another, the base image often must be knocked out so that the second image can be reproduced right on the paper and not on top of the first image.

Ku band
A satellite-based data transmission *network* with a transmission capacity of approximately twelve *gigahertz*.

L*a*b* color space
See *CIE color space*.

LAN
Acronym for local area *network*, a group of interconnected computers in one geographical area that share resources.

land line
A copper wire or *fiber optic* cable, above or below ground, that is used to send data. A telephone *system* is a typical example.

landscape
Describes a horizontal orientation of a page *format*, as opposed to *portrait*, which is a vertical orientation.

laser
Acronym for light amplification by stimulated emission of radiation. A laser is a device that produces a very narrow light beam, consisting of straight parallel rays of a given wavelength *(color)*, for the purpose of exposing light sensitive photographic films, photographic papers, cylinders or *printing plates*.

laser diode

A solid-state miniature *exposure* lamp emitting a small *spot* of light, usually in the infrared region. Laser diodes are used in some imagesetters. See also *helium neon laser*.

laser printer

A *desktop* output device that produces images from *digital data* on paper or film. The images can be text, graphics or *halftones*. Somewhat like a photocopying machine, the laser printer's cylinder is electronically charged to make it light-sensitive. The cylinder is exposed with a *laser* to create the invisible latent image that will accept *toner* particles. The *toner* is applied, the particles are transferred from the cylinder to the paper, and fused with heat and pressure.

layer

In graphics software, objects can be created or arranged on different overlaying planes, to ease handling and organization.

leaders

Dashes or dots used in a series to create lines intended to direct the eye from one block of text to a second block of text or numbers, as in a price list or a table of contents.

leading

(LEDD-ing) The amount of space between two lines of type that is described as the distance between *baselines*—also called line space.

lead screw

(LEED screw) Located inside a *scanner*, a long narrow shaft with threads upon which the *nut segment* (half a nut) rides to control the optics movements across the cylinder. The lead screw is sometimes called the spindle.

lease line

A communication line rented by a company for its exclusive use in transmitting data files.

LED

Abbreviation for light emitting diodes, miniature light sources that are used for electronic digital displays and to expose film and paper in output devices.

Letraset ColorStudio

See *ColorStudio*.

letterpress

A method of printing from *plates* with raised images. There are four types of letterpress presses: platen, *flatbed* cylinder, rotary and belt.

letterspacing

The process of increasing or decreasing the space between letters in a block of text. Letterspacing is used as part of the *h & j* process, or to create a special typographic effect. Today letterspacing can be accomplished with *software*; in the past lead spacers were manually inserted between the letters. Contrasted to *kerning*, a process of selectively reducing space between characters to improve the visual letterspace balance.

levels of gray

See *gray levels*.

LHUG

See *Linotype-Hell Users Group*.

ligature

By typesetting tradition, certain *characters* typeset together with all the space between them removed—as if they were just a single *character*. Examples are ae, fi and fl, set as æ, fi and fl. In a type *font*, each ligature is created as a separate *character*, and generally is accessed by separate keys.

lightness

Degree of *brightness* or darkness of a black-and-white or colored image, regardless of its *hue* or *saturation*.

limiter

A control that prevents a *scanner* or *system* from exceeding a minimum *highlight* or a maximum *shadow* amount when making *separations* for reproduction. Limiters are set by the operator based on identified limitations of the printing process.

linearization

The process of calibrating all of the optical, physical and electrical elements of an imaging *system* to control the variables for predictable results to optimize and control the image quality. Some of the necessary considerations are the adjustment for the film chosen, processing, *exposure* amount, speed, light source, *focus*, zoom, signal strength, voltage and amperage.

line art

See *line work*.

line copy

High *contrast* reflective artwork, with no shades of gray, preferably in black-and-white, although colors can be photographed with appropriate *filters* and film—see *line work*.

lines per inch (lpi)

Number of input scans or output exposure lines in a linear inch. *Halftone screens* are rated in lines per inch, which represent rows of *halftone dots* per linear inch. For example, a 150-line *screen* would consist of 150 rows by 150 rows of *halftone dots* creating 22,500 *dots* in one square inch.

line work

1. (adjective) A generic term to describe high *contrast original* or reproduced images (films, *plates,* flats, etc.) containing no shades of grays, halftones or *tints.*
2. (noun) In the documentation of some *CEPS* the term is used to refer to files in linework *format.*

Linotronic™ output

Usually a reference to *PostScript* image *files* recorded on a Linotronic series *imagesetter* from Linotype-Hell. "Linotronic output" is often used generically to refer to *imagesetter* output.

Linotype-Hell Users Group (LHUG)

The non-profit association of users of Linotype-Hell Company *scanners, imagesetters* and color *systems.*

lithographic

See *lithography*.

lithography

A process that prints from flat *plates* using water to repel the ink from the nonimage areas of the *plate*. The images are first printed to a rubber blanket and then offset to paper, thus the popularity of the name "offset" or offset lithography.

local correction

A *color correction* technique that is applied to small identified areas of an image. While local correction may only

pertain to an object or area in a picture, *global correction* is done to the entire image.

look-up table (LUT)
A two- or three-dimensional array of values stored for given input-output relationships. When one input value is known, the *system* can automatically determine the correct output value. For example, the *system* can find the needed *dot size* for a given set of printing conditions based on the stored *gray level*—see also *CLUT*. The alternative to a look-up table is a *transformation algorithm*.

lossless
Data compression that does not result in any loss of data.

lossy
Data compression that achieves its high compression rate by sacrificing what is judged to be an acceptable amount of data.

low-key transparency
A dark, possibly under-exposed, *transparency* that contains most of the important detail in the *shadow* area.

low resolution file
See *coarse data file*.

lpi
Abbreviation for *lines per inch*.

luminance
The *lightness* or *brightness* picture attribute with no regard to its other attributes, such as *hue* and *saturation*.

luminosity

A term used to describe *brightness*. The term is not commonly used today.

LUT

Abbreviation for *look-up table*.

LUV

See *CIE color space*.

LW

Abbreviation for *line work*.

LZW

Abbreviation for Lempel-Ziv-Welch, a *lossless data compression algorithm*.

M
Abbreviation for one thousand.

Mac
Abbreviation for any model of the Apple *Macintosh* personal computer.

MAC
Abbreviation for Magazine Advertising Canadian Specifications, *color separation* and *proofing* specifications similar to *SWOP*.

Macadam units
On a *chromaticity diagram*, elliptical shaped areas that indicate one just-noticeable-difference in all three attributes of *color*.

Macintosh®
A brand of computer manufactured and marketed by *Apple Computer Inc*. With its graphical display and support for Adobe *PostScript*, the *Macintosh* first popularized *desktop publishing*.

The Macintosh Classic

Macintosh operating system

The *system software* that is used on *Macintosh* computers to control essential computer functions, such as *disk* formatting, *file* locating and printing. Unlike *MS-DOS*, the name of the *operating system* used on IBM-PC and compatible computers, the Macintosh operating system has no other formal name. *System 7* is the most recent version of the Macintosh operating system.

macro

Sets of computer commands connected together with *software* so that they can be executed with a single command.

magenta

1. The subtractive *primary color* that appears bluish red and absorbs *green* light.
2. One ink in the four-*color* printing process—sometimes referred to as "process red."

magnification

The relationship of the size of the *original* to the size of the reproduction, expressed as:

$$M = i/o$$

Where M is the magnification factor, i is the image size, and o is the size of the *original*.

makegood

A rerun of a printed advertisement, done without charge, because of an advertiser's or publisher's *ad complaint*.

makeready

The process of making the adjustments on a printing press for a particular ink, paper and set of printing conditions, prior to the *pressrun* and up to receiving the *color* OK—see *OK sheet*.

management information system

See *MIS*.

MANI

The name that is used by Linotype-Hell Company for the ChromaCom *system file format*.

MARKOLOR™

A patented graphic process of interpretive condensing of all graphic information from full color artwork through a series of filters or scans to two films, impulses or impressions. MARKOLOR separations are printed with two colors, usually red and green, red and black or red and blue. MARKOLOR separations can be printed on a wide range of materials using a wide range of printing processes.

mask

A photographic film placed over an image in order to modify the light that will pass through the image, thereby changing a characteristic of the reproduction. This task can also be handled electronically on digital prepress *systems*. There are a variety of masks, including *area masks, outline masks* and *unsharp masks*—see *unsharp masking (USM)*.

masking equations

Mathematical expressions of the relationship between the amounts of ink printed and the resulting *red, green and blue* densities or reflectances. These equations are used in an attempt to correct for the *hue errors* of a given ink set.

Matchprint™

An *off-press, single sheet color proof* manufactured by 3M. Matchprint is comparable to *Cromalin*. *Color-Key* is a 3M *overlay color proofing* system.

matte

A dull or rough surface, lacking gloss or luster, such that more light is reflected to the eye, and colors appears less dense.

maximum density

The heaviest *density* achievable with a given imaging *system* or material. For example, in printing the maximum density might be 2.0 for coated paper, 1.6 for uncoated paper and 1.2 for newsprint—also called *Dmax*.

MB or Mb

Abbreviation for *megabyte*, a measure of data quantity that is roughly one thousand kilobytes or one million *bytes*, but in fact, is 1,048,626 *bytes* or 2^{13}. *RAM* and *hard disks* are usually measured in MBs.

Complete Color Glossary

measured photography
A method for precisely measuring the illumination of all scene areas on the camera image plane. The purpose is to assure proper illumination of the scene so that critical areas are not too dark to properly reproduce—previously called *4-stop photography*.

mechanical
Complete pages, with text, *line art* and *crop marks* in position, ready to be photographed for reproduction—described as *camera-ready art*.

mechanical color separation
A manual *color separation* technique, as opposed to an electronic or photographic technique. The artwork for each *color* is manually prepared on a separate board or overlay.

megabyte
See *MB*.

megahertz
A unit of *frequency* equal to one million cycles per second. Microcomputer processing speeds are generally indicated in megahertz—see *hertz*.

memory colors
Familiar colors that are regularly seen in common objects, such as *blue* sky, *red* apples, *green* grass and human flesh. *Color* separators should adjust the *tone reproduction* and *color correction* so that memory colors appear natural.

menu
A list of command choices shown on a computer *screen*, from which a user can select a command, either with a *mouse* or a keyboard.

A portion of a QuarkXPress menu

menu driven

Software that is operated via *menus* rather than via keyboard commands. The menus are usually accessed with a mouse or stylus pen.

metameric color

(meh-ta-MER-ic color) A *color* that changes its perceived *hue* under different illumination. For example, it is possible to have two *color* samples match under tungsten illumination and not match when viewed in sunlight.

metamerism

(meh-TAM-er-is-m) The phenomenon that causes the same colors viewed under light from different sources to appear differently. The colors seem to change with different illumination—see *metameric color*.

metric

A standard of measurement that is based on the meter (39.37 inches) and widely used throughout most of the world outside of the United States. Most *high-end scanners*

and *color* electronic publishing *systems* operate in metric formats, that is, millimeters and centimeters.

microprocessor
A small computer built into a single computer chip, designed to carry out a series of functions, calculations or production steps. In *desktop* computers, the microprocessor is the main chip and contains the entire central processing function. The *Macintosh* computer uses Motorola microprocessors; *IBM* and compatible computers use Intel microprocessors.

Microsoft Windows
See *Windows*.

middletone
Tonal values of a picture, an *original* or a reproduction, midway between the *highlight* and *shadow*—also called midtone.

middletone placement
The location on the original *gray scale* where *middletone* output values are placed. During *scanner* setup, the operator must tell the *scanner* where to place the *diffuse highlight*, the *shadow* and the *middletone dots* relative to the input setup

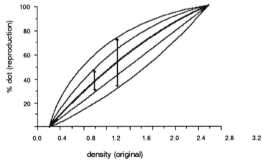

Middletone placement

scale so that the *tone reproduction* curve will be correct for each original and the printing process to be used. This process determines the *middletone dot sizes*. Therefore, it also determines the *tone reproduction (contrast)* of the reproduction. Incorrect setting of *middletone dots* is the largest single cause of poor quality *color* reproductions. Failure to compensate for the *dot gain* of the printing process, paper and screen ruling to be used may yield a *color* reproduction that is dark and has colors that appear dirty. The *scanner* middletone placement control has more influence on producing clean, bright reproductions with any ink, paper and printing conditions than any other *scanner* control.

midrange system
A page makeup *system* priced between low-end *desktop systems* and *high-end CEPS*. Midrange refers to the cost of the equipment, rather than the equipment or its output quality. Midrange systems may or may not use *PostScript*, and may or may not use *desktop* computers. These *systems*, computer and *software*, bundled with a *scanner*, *proofing* device and an output *film recorder*, are priced generally in the $250,000 range.

midtone
See *middletone*.

mil
Abbreviation for 0.001 inch, one one-thousandth of an inch.

millimeters to inches
To convert from a measurement in millimeters to a measurement in inches divide the millimeters by 25.4 (or centimeters by 2.54). 1 inch = 25.4 mm.

minicomputer

Medium-capacity computers, more powerful than a *workstation*, but less powerful than a mainframe computer. The DEC *VAX* (Digital Equipment Corporation VAX) is a popular model of minicomputer—sometimes used for digital publishing applications.

minimum density

The lowest *density* amount measurable on a given sample, or producible on a given material or a device display—called also *Dmin*.

MIPS

Acronym for million instructions per second. MIPS are a standard speed rating for *workstations* and for higher power personal computers. Some observers discredit MIPS ratings as power indicators, and say that MIPS stands for meaningless indicator of processing speed.

MIS

Abbreviation for Management Information System, a computer *system* that is used to record, analyze and report on production data, such as times, costs, rates, materials, functions and *file* locations.

modeling

The process of rendering *shading* details in a picture so that objects appear to be three dimensional, have surface texture or have relief, such as the ripple on an orange peel or the texture of a woven fabric. The least predominant *color* usually produces the detail, but too much of least predominant *color* will darken the overall image.

modem

Acronym for MOdulator/DEModulator, a hardware device that is used to send information, usually over telephone wires, from one computer to another. Modems can be external, in a separate case, or internal, on a circuit board.

A modem

modulate

1. To control and change the values of data.
2. To vary the amplitude, *frequency* or phase of a carrier signal with a data signal to allow electronic devices to communicate data between components.

modulator

A device that varies the light output for each beam of light imaging the photographic film, photographic paper, *printing plate* or cylinder. There are three types of modulators, crystal, acoustical and optical.

moire or moiré

An objectionable interference pattern caused by superimposing one regular pattern over another such as with *halftones* or *screen tints*. Moirés can be caused by misalignment, incorrect *screen angles*, slipping or *slur*. They can usually be minimized by placing one *screen* over the other *screen* by a 30 degree angle difference.

monitor

A computer video display.

monochrome
A single *color*. Usually, monochrome refers to a black-and-white image.

monospaced type
A typeface where each *character* occupies the same amount of total space. With thin *characters*, such as the letter "l," white space is added on each side so that it occupies the same amount of space on a line as the letter "m." Manual typewriters could handle only monospaced type; typesetters handle proportionally spaced type.

mounting (oil)
See *oil mounting*.

mouse
A movable, hand-held plastic *mechanical* device that is a component of most *desktop* computers. Movement of the mouse on a pad placed on a flat surface causes corresponding movement of images and cursors on the *video monitor*. The mouse functions similarly to a *track ball* or *joy stick*. It is connected to the computer by a wire giving it the appearance of a mouse.

MPEG
Abbreviation for Motion Picture Experts Group, an *ISO* group that is working to establish a standard for the compression of moving digital images. See also *JPEG*.

MS-DOS®
Abbreviation for Microsoft disk *operating system*. MS-DOS is the name of the *operating system* of IBM-PC and compatible computers. Often just called DOS, it is used by some 40 million computers around the world. Most computers that

use DOS also use various extensions, such as *Windows* 3.0, to increase DOS's power.

MultiFinder

A feature of the *Macintosh operating system* (in versions prior to *System 7*) that allows more than one *application* to be open at one time.

multisync monitor

A *computer color* video display that can work with more than one type of video input board.

multitasking

The capability of a computer to run more than one *application* at one time. The *Macintosh MultiFinder* can keep more than one *application* open at one time. However, it is not truly multitasking because it cannot actually process data in more than one *application* at one time.

Munsell color space

A widely-used *color system* (with *color* chips) using *hue*, *chroma* and *value*. Munsell is based on human perception and the visual differences of the three color attributes.

nanometer
A measurement of a wavelength of a light beam, which is abbreviated nm. A nanometer is 10^{-9} meters (a billionth of a meter). The wavelengths of various lights in the *visible spectrum* are as follows:

blue light	400 to 500 nm
green light	500 to 600 nm
red light	600 to 700 nm

NAPLPS
Abbreviation for North American Presentation Level Protocol Standard, a data *format* that is used in presentation and charting *software*, and in videotex systems.

NAPS
Abbreviation for negative-acting proofing system, a Hoescht-manufactured *overlay color proofing* system, similar to 3M's *Color-Key* proofs.

narrowband
Refers to the *bandwidth* opening of an optical *system* or *color filter*. A narrowband does not let as much information pass through as a normal or *wideband* opening.

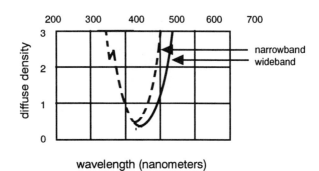

Narrowband /Wideband

negative

1. A film that has the light and dark parts tonally reversed from those of the *original copy*.
2. The film image of a completed page that is used to make a negative working *offset printing plate*, which will produce a *positive* printed image.

negative working plate

A *printing plate* that is exposed through a film *negative* and used to print a *positive* image.

network

The interconnection of computers and *peripherals*, ground stations and satellites, or people, for the purpose of exchanging information. A computer network is electronically interconnected, individually controlled computers, plus the hardware and *software* that is used to connect them. On a *LAN*, all users share data and/or *peripheral* devices, such as *scanners*, printers and storage media. Computer *networking* takes another form when *color* trade shops utilize telephone *modems* to transmit or receive picture files to and from their customers or other trade shops—see *Ethernet, IFEN* and *wide-area network*.

Satellite networks interconnect, with radio wave relays, several national and international ground sites by using several satellites 22,000 miles over the equator. A ground antenna in a key location has contact with only one satellite. These networks may be point to point (one ground station sending via one satellite to another ground station), multipoints to point (several ground stations sending information via one satellite to one ground station), and point to multipoints (one ground station sending information by one satellite to several ground stations). Newspapers use the point to multipoint approach.

A people network is a group of individuals, known to one another, who do similar tasks in different locations and contact one another in person, or by telephone, modem or fax to share information—see *sneaker net*.

networking

The process of connecting or linking computers and *peripherals*, ground stations and satellites, or people with people so that information can be exchanged—see *network*.

Neugebauer equations

Three equations that can predict the *red, green and blue* reflectances that will result from given *dot areas* on a printed sample.

neutral density

Optical *density* that is gray with no apparent *hue*. The term, neutral density, is used to describe photographic images, printed images or optical *filters*.

neutral gray

Any level of gray from white to *black* that has no apparent *hue* or *color*. A printed neutral gray may have the same appearance as one of the steps of a photographic *gray scale*.

Newton rings
The objectionable, irregularly shaped, colored circles that are caused by the prismatic action of interfacing different smooth surfaces such as a piece of film in a contact frame or a *transparency* on a *scanner* cylinder.

NeXT™
A computer company founded in 1985 by Steve Jobs, the co-founder of Apple Computer. NeXT offers high-power low-price computers running a variation of the UNIX operating system. The NeXTdimension™ is a 32-bit color computer.

noise
Unwanted optical signals or electronic signals that decrease the difference between the high and low values and increase the errors during receiving, storing or processing of data. Optical noise is called flare or glare, and electronic noise is called static.

nondiscrete value
Something that can be measured to the degree of precision desired, limited only by the characteristics of the measuring device, as opposed to a *discrete value* that can only vary in whole numbers. For example, the *discrete value* is the number of *separations* that were made. Five were acceptable and two were not. The degree of correctness of each *separation* is a *nondiscrete value*.

nonreproducible colors
Certain colors in nature and photography that cannot be reproduced using process inks. The *color* of the *original* is outside the *color gamut* that the inks can reproduce. For example, a very dark, deep, rich wine red—see also *out-of-gamut alarm*.

north pulse
On a *drum scanner*, the beginning reference point, set by the *scanner* operator, at the top of a scanned image.

NTSC
Abbreviation for National Television Standards Committee, the organization that set the U.S. *color* television standard of 525 lines on the video display and 30 frames per second.

nut segment
Located inside a *scanner*, a threaded nut, cut in half, that rides on the *lead screw* to control the *crossfeed* of the *scanner* input or *output optics*. The half-nut design allows the operator to raise the nut segment off the *lead screw* to stop movement.

office environment
See *environment*.

off-line
1. (adjective) Describes a component or device that is used in conjunction with a *system* but is not connected to the *system* or *network*. An *off-line* device functions without tying up the *network*. For example, an *off-line* prescan analyzer is used to perform the *prescan analysis* function separate from the *scanner* prior to scanning. The information is input into the *scanner* by the operator using the manual controls or a floppy computer *disk*.
2. (adverb) For a component or device within a *system* or *network*, the state of not being currently connected.

off-press proof
A *color proof*, which simulates the appearance of the printed reproduction, made without the aid of a printing press, using pigmented or dyed light-sensitive materials exposed with the film *negatives* or *positives*. An off-press proof may be an *overlay proof* or a *single sheet proof* and may be treated or not treated with post finishes to simulate the gloss of the printed reproduction—also called a *prepress proof*. Some common types of off-press proofs are *NAPS*, *Color-Key* (both *overlay color proofs*), *Cromalin* and *Matchprint* (*single sheet color proofs*).

offset alignment
An internal adjustment of the electronic components of a *color scanner's* analog *color* computer.

offset lithography
See *lithography*.

offset printing
See *lithography*.

off-the-shelf
Software that is sold through retail channels—also called *shrink-wrapped software*.

oil mounting
The act of attaching *transparencies* on a *scanner* drum in a layer of paraffin oil or mineral oil to eliminate scratches or *Newton rings*.

OK sheet
A *proof* or a printed press sheet that is taken during press *makeready* or from the beginning of the *pressrun*, evaluated, marked "OK," signed and used as a *color quality control* guide for the rest of the *pressrun*—also called *pass sheet* or *color OK*.

on-line
An adjective describing a component or device that is connected to a *system*, and receives, transmits and deciphers signals from the *CPU*.

on-the-fly
Computer operation in *real time*. A computer function takes place on-the-fly when there is no apparent delay in its execution.

opaque (opaquing)
1. (noun) Capable of blocking the transmission of all light—the opposite of *transparent*.
2. (verb) Blocking part of a film *negative* to avoid reproducing a flaw or unwanted image area. Opaquing is usually performed with opaquing fluid on a brush or with a special opaquing felt-tip marker.

open architecture
Refers to computer *systems*, such as *Macintosh*, IBM-PC and compatibles, or *UNIX workstations*, running on *standard platforms* that can easily be connected to a range of *peripheral* devices.

Open Prepress Interface
See *OPI*.

open up shadows
A *color scanner* or *system* command to change *contrast*, making it possible to reduce *shadow three-quartertone* areas in an attempt to reproduce more *shadow* detail.

operating system
The master control program that gives any computer its basic personality. Operating systems direct all of the information moving around inside the computer. Operating system functions include user-accessed commands for everyday tasks, such as copying files, examining the content of a diskette, and so on. The most common operating systems are *MS-DOS*, *OS/2*, *UNIX*, and the Apple *Macintosh operating system*.

OPI
Abbreviation for Open Prepress Interface, a communication connection developed by *Aldus Corporation* that facilitates

links between *CEPS* and *desktop publishing systems*. Using OPI, *viewfiles* of full *resolution* scans can be transferred to *desktop publishing systems* and placed in *page layout software*. When the page *file* is sent back to the *CEPS* for processing and output, the high *resolution* image data is automatically swapped for the *viewfile*. OPI is now frequently used by any *system* that seeks to maintain high *resolution* image data separate from page layout files. OPI is often compared to *DCS*.

optical disc
A thin, flat, circular plate similar to a phonograph record that is capable of storing large amounts of data. Images are exposed on the *disc* surface using a *laser*. These *discs* can be either *ROM, WORM* or *rewritable optical discs*.

optical dot gain
When *dots* are printed on paper, some of the light that should reflect off the surface of the paper is trapped under the edge of the *dot*, increasing the *density* of the area. Rough textured papers or finer *screen rulings* will increase the darkening effect. *System Brunner* labels this the "Border Zone Theory."

original
Refers to the *copy* furnished by the customer for reproduction, such as artwork, *transparency*, *reflection copy*, painting, etc.

orphan
In typography, an orphan appears when the first line of a paragraph is the last line of a page.

orthochromatic
Describes a film's sensitivity. Orthochromatic film is exposed by ultraviolet, *blue* and *green* light but not by *red* light.

Often, orthochromatic film is used for *line work* and *halftones* in a process camera—see *panchromatic*.

OS/2

The *operating system* created by Microsoft and *IBM* to be the successor to *MS-DOS*. OS/2 offers a number of advanced *system* features, such as *multitasking*, the capability to process data in more than one *application* at one time.

outline mask

The electronic silhouette created on a *CEPS* or *color desktop publishing system* to isolate a picture element from the rest of the picture content—see also *unsharp masking (USM)*.

out-of-gamut alarm

A *software* feature in color image editing *software* that identifies image areas shown on the video display which exceed the printing *system's color gamut*—see also *nonreproducible colors*.

output optics

The optical lenses, light sources, *beam splitters*, *modulators* and focusing devices that make up the light path of an output *exposure* unit.

overcorrection

Occurs during the *color separation* process; while attempting to *color* correct for the *hue error* of the printing inks, too much of the contaminating *color* is removed. The result is that the *modeling* or detail is removed, and the *color* is too light or clean in the reproduction. Overcorrection is the opposite of *undercorrection*.

overlay color proof

A *color proof*, which simulates the appearance of the printed reproduction, made off press with overlaying *color* layers of *cyan, magenta, yellow* and *black*; each *color* is on its own thin film membrane. Two common types of overlay *proofs* are *Color-Key* and Cromacheck.

overprint

To print *dots* of one *process color* ink over *dots* of another *process color* ink to produce *overprint colors* or secondary colors, such as *red, green and blue*.

overprint colors

Secondary colors, such as *red, green and blue*, that result from printing *dots* of one *process color* ink over *dots* of another *process color* ink.

page description language
Software that can describe an entire page, including text, lines, *screens* and graphics. *PostScript* is by far the most popular page description language for electronic publishing.

page geometry
The description of the positions and shapes of each element in a composed page.

page interchange language
See *PIL*.

page layout software
See *page makeup software*.

PageMaker®
A *software* program used for page makeup, published by Aldus Corporation. PageMaker is available for *Macintosh*, IBM and *IBM-compatible computers*.

page makeup software
The category of *desktop software* that is used to create composed pages of text and graphics.

paint program
Software, sometimes referred to as painting software, that creates black-and-white or *color* digital images with *bitmap graphics*.

PAL
Abbreviation for Phase Alternation by Line, the West European television broadcast standard of 625 lines and 25 frames per second.

palette
See *color palette*.

panchromatic
A film sensitive to all colors of light. Panchromatic film is used to make photographic *color separations* from *color originals*. Electronic *color scanners* can use either *orthochromatic* or panchromatic sensitive films because the film is exposed by a *laser*.

Pantone Matching System (PMS)
Color charts that contain 747 preprinted *color* patches of specially blended inks, used to identify, display, and/or communicate specific colors. Both designers and printers utilize the *system* so that colors can be matched exactly. The Pantone Matching System remains the most popular *color matching system* for designers and publishers. Pantone also offers a Process Color System with 3,000 process color combinations. See also *TRUMATCH* and *Focoltone*.

parallel processing
The capability of a computer to simultaneously perform multiple computations.

parity check
A verification technique that is used to check that a string of data has been correctly transmitted. A *character* or number is added to the string of data to make it odd or even, depending on which has been chosen for parity.

pass sheet
See *OK sheet*.

paste up
Placing graphics and text in a *mechanical*, either manually or electronically.

PC
1. Abbreviation for personal computer.
2. Abbreviation for *print contrast*.

PC clone
See *IBM-compatible computer*.

PC-DOS
IBM's brand-name for *MS-DOS*.

PCX
Abbreviation for PC Paintbrush EXtension, a *bitmap graphic format* originated for use with ZSoft's PC Paintbrush *software* and now widely used with *IBM-compatible computers*.

PDL
Abbreviation for *page description language*—see also *PostScript*.

PDX
Abbreviation for Printer Description Extension file, a *file* specification set by *Adobe Systems* that is used in conjunction

with *PPDs* to include user-definable output device information, such as special output page sizes.

PE
Abbreviation for printer's error, a problem with either the type, color separations, *plates* or printing; the cost of the correction will be borne by the printer or prepress service, rather than the author, designer or publisher—see *AA*.

peaking
1. A *color scanner unsharp masking* function that electronically adds two signals and increases the edge *contrast* of an image to be reproduced.
2. Electronic *edge enhancement* produced on the *color separation negatives* by exaggerating the *density* difference of image edges.

pel
Acronym for picture element. *Pixel* is more commonly used than pel. Pel refers to video picture elements.

percent dot area
See *dot area*.

peripheral
Any device that is an add-on component to a computer *system*. Each is physically separate from the main unit and connected to it by a wire or cable. In the case of the *PC*, a peripheral is hardware, such as a *disk* drive, *scanner*, printer or *modem*, that is used in conjunction with the computer and controlled by it.

persplex
A plastic material, similar to Plexiglas, that is used to make *scanner* drums.

PEX
A graphic standard for the interchange of *PHIGS+ format* data between *workstations* supporting the *X Windows interface*.

PHIGS
Abbreviation for Programmer's Hierarchical Interactive Graphics System, a data *format* for 3-D graphics programming.

PHIGS+
An *extension* to the *PHIGS* graphic standard that includes data about lighting, *shading* and advanced *primitives*.

photodiode
A light sensitive photocell on a computer chip that can measure the amount of light falling on its surface.

photodiode array
In a *scanner*, a series of *photodiodes* arranged in a line to sense numerous *pixels*, either simultaneously or sequentially, during input scanning.

photomultiplier tube (PMT)
See *PMT*.

Photoshop™
A *software* program for the *Macintosh*, published by *Adobe Systems*, that is used for image scanning, *retouching* and correction.

PhotoYCC
A *color space* definition used in the Eastman Kodak Photo CD System. It is based on the use of one *luminance* and two *chroma* record channels.

physical dot area
The actual coverage of *halftone dots* in a given area, expressed as a percentage.

physical dot gain
The increase in actual *dot size* from the *halftone dot* on film or the *dot* in a computer *file* to the same *dot* printed.

pica
A unit of measure that is commonly used in typesetting and design. A pica is one-sixth of an inch. There are 12 *points* in a pica.

pi characters
The special *characters* used for setting mathematics, forms, etc. Examples include ■ ✓ ✆ ★ ✗ ❑. Many *desktop publishing systems* include the *font* Zapf Dingbats which is comprised of pi *characters*.

PICT
A *Macintosh format* for storing black-and-white *vector* and *bitmap graphics* using Apple's *QuickDraw* imaging routines.

PICT2
A variant of *PICT* used for describing *32-bit color files*.

PIL
An acronym for Publishing Interchange Language, a proposed standard for exchanging *page geometry* information between different *page makeup software*.

pivot point
The hinge point of a curve or the location where a linear function changes.

pixel
Acronym for picture element, the smallest picture sample that can be sensed, manipulated or output by a digital *system*. In a *color system* each pixel is represented either by a *CMYK* or *RGB* value.

pixelization
A special image effect created by averaging and reducing the number of *pixels* in an image. The result is that much of the detail of the *original* object is lost.

pixel replication
See *pixel swopping*.

pixel swopping
A *color retouching* technique to exchange *pixels* from one area of a picture for *pixels* in another area. The process is used to alter the reproduction, remove blemishes and scratches, and/or add objects. For example, a window may be removed from a brick building if another area of the brick wall is placed in this window area of the picture.

plate
See *printing plate*.

plotter
A device that exposes photographic film or paper, *printing plates* or cylinders in a sequential *raster* fashion—see also *film plotter*.

plug & play
Equipment, *peripherals* and *software* that can be operated immediately after purchase without extensive installation and training.

PMS
Abbreviation for *Pantone Matching System*.

PMT
1. Abbreviation for photomultiplier tube, which is usually referred to as a photomultiplier when the abbreviation, PMT, is not used. A PMT is a light-sensitive tube that can sense very low light levels by amplifying the signals applied to it during the sensing. PMTs give drum *scanners* their superior *color separation* capabilities.
2. Abbreviation for photomechanical transfer, another name for a black-and-white diffusion transfer print.

point
A unit of measurement that is commonly used to specify type sizes. A point is equal to O.0138 inches; there are 72 points in an inch.

port
A connector or electrical plug on a computer or *peripheral* device for input and/or output of data.

portable color
See *color portability*.

portrait
An adjective describing a vertical orientation of a page *format*, as opposed to *landscape*, which is a horizontal orientation.

position proof
A *color proof* used to verify that all the elements of the reproduction (text, graphics and pictures) are in the correct location and in *register* with each other. Usually, a position proof does not contain the correct *color* strengths or *hues*

for *color* judgment. Common types of position proofs are IMPRINT, Recoprint and Doublecheck.

positive
1. A film that has the light and dark parts tonally correct as compared to those of the *original copy*.
2. The film image of a completed page that is used to make a *positive working offset printing plate*, which will produce a positive printed image.

positive printing
A term that refers to the process of printing with *positive working plates*. The U.S. printing industry is traditionally *negative* based. Europe, on the other hand, is *positive working*. *Positive working plates* have a 5% *dot* loss that reduces the *middletone dot size*. This negative dot loss is an advantage for *web-offset* printing because of the extra *dot gain* found on *web-offset* presses. When *negative working plates* are made, they have a 2% *dot gain*.

positive working
The process of printing using *positive separation* films, *flats* of assembled film *positives* and *positive printing plates*, rather than *negative separations* and *printing plates* as used in *negative* working printing.

positive working plate
A *lithographic printing plate* that is exposed through a film *positive* and used to print a *positive* image.

posterize
A special visual effect created by setting a defined number of gradient steps in a *bitmap* graphic.

PostScript®

A *page description language*, developed by *Adobe Systems*, consisting of a specific set of *software* commands and *protocols* that form images on output printers and *film recorders* when translated through a *RIP* (raster image processor). The key feature of PostScript is *device independence*, which allows many different output devices from different manufacturers to print the same *file* in more or less the same way.

PostScript clone

A *RIP* (raster image processor), in hardware or *software*, which interprets *PostScript* files, designed and/or manufactured by a company without authorization or engineering assistance from *Adobe Systems*. Images generated by PostScript clone *RIPs* ordinarily appear identical to those that would be created by a true *PostScript RIP*. Usually the term, PostScript clone, is used generically to refer to any *laser printer* or *imagesetter* employing such a *RIP*. PostScript clones are described as *PostScript-compatible*.

PostScript-compatible

A device that can interpret Adobe *PostScript* commands but was not designed or manufactured under license from *Adobe Systems*—see *PostScript clone*.

PostScript Level 1

The original version of *PostScript* is usually referred to just as "PostScript," not as "PostScript Level 1," although the revised version is called *"PostScript Level 2."*

PostScript Level 2

A revised version of *PostScript*, released in 1991, designed to provide expanded support for *process color* publishing (among other enhancements). PostScript Level 2 includes

definitions for *color space* and procedures for *color* image *data compression*.

power stabilizer
A transformer that is used to insure that the electrical power feeding a computer or *system* has a constant voltage.

PPD
Abbreviation for PostScript Printer Description file, a *file* specification set by *Adobe Systems*, containing information about specific performance characteristics of an output device. PPDs are used by *desktop publishing software* to ensure that output remains within the capabilities of the chosen output device.

prepress proof
See *off-press proof*.

prescan analysis
The process of examining *original color transparencies* to determine their tonal characteristics, either by measuring, or by comparing them to reference *transparencies*, for the purpose of making an optimum *scanner* setup.

Presentation Manager
The portion of the new *OS/2 operating system* that defines the user *interface* and is similar to *Windows*.

press gain
See *dot gain*.

press proof
An image printed before the production *pressrun* to verify that the desired effect can be achieved, using the produc-

tion inks and production *substrate*. The press may or may not be the one used for the production *pressrun*.

pressrun
the actual running of the press to print the job, immediately following the *makeready*.

primary colors
The colorants of a *system* that are used to print the colors for the entire reproduction. *Cyan, magenta and yellow* are *subtractive primary colors* while *red, green and blue* are *additive primary colors*.

primitive
The most basic graphic entities, such as points, lines, geometric shapes and *characters*.

print contrast (PC)
A method that is used to measure and optimize the solid ink *density*, *dot gain* and *shadow contrast*, by adjusting the ink strength. During the *pressrun*, the solid ink *density* and the 70% *tint density* are measured. *Print contrast* is then calculated as follows:

$$PC = \frac{D_s - D_t}{D_s}$$

Where PC is print contrast, D_s is the density of the solid, and D_t is the density of the tint.

printer description languages
See *page description language*.

printer driver
See *driver*.

printer fonts
Computer files containing the image outlines for type in *PostScript format* or in another *page description language format*. When type is created in a *software* program, the data in the printer *font* is called to supply the necessary typographic information to the *file*. *Screen fonts* supply the same type of information to the computer *monitor*.

printer's error
See *PE*.

printing plate
An intermediate image carrier used on a printing press to transfer the image from the film or a digital file to the *substrate*—see *negative working plates* and *positive working plates*.

printing sequence
The order in which *process colors* are laid down using a four-*color* printing press. Worldwide, the most popular order for *lithography* is *black* followed by *cyan, magenta* and *yellow*.

process color
The statement, "The reproduction will be printed using process *color*," indicates that *color separations* will be made and printed using process *color* inks. When four *separations* are made, process *color* is also called *four-color process*.

process colors
The printing ink colors, *cyan, magenta, yellow* and *black*.

process control
The tools and methods for keeping each production process within acceptable limits to minimize product variation.

prog
An acronym for progressive proof, a series of *color proofs* that include the finished four-*color proof*, a three-*color proof*, each individual *process color* and two-*color* combinations of each process ink, which makes it possible to see each combination of colors separately. Progs are printed with ink-on-paper and used for press control when visually compared to the press sheet.

progressive proof
See *prog*.

prompt
A flashing signal, dialog box or command on a computer *monitor screen* that waits for a response from the operator.

proof
See *color proof*.

proofing
The technique of making a proof, the visual impression of the expected final reproduction. There are many proofing methods depending on the type of proof that is need. The most common types of proofs are *contract proof, DDCP, digital proof, hard proof, off-press proof, overlay color proof, position proof, press proof, prog, single sheet color proof* and *soft proof*.

proofing stock
Special paper for making *color proofs* that will appear like the printed reproduction.

proof marks or proofreader's marks
A widely-accepted *system* of notations used to indicate corrections or alterations required on a area of type.

proprietary systems
A publishing *system* that runs on hardware other than *standard platforms*. Proprietary systems, considered closed, are limited in their ability to exchange data with other publishing *systems*.

protocol
A specific set of instructions that regulate data exchange between computers—see also *communications protocol*.

proxy file
See *viewfile*.

pt.
Abbreviation for *point*.

Publishing Interchange Language
See *PIL*.

puck
A movable, hand-held plastic rectangular device that contains control buttons and a cross-hair target. A puck is used on a *digitizing tablet* to move images and the cursor on a *video monitor screen*.

Q-60
A *color scanner* calibration kit offered by the Eastman Kodak Company.

quad
A square space the size of an *em* that was used in lead typesetting to space out a line to its full justified width so that each letter was held in place when the frame was moved. For example, to *quad right*, the typesetter placed all the quads on the left side of the line to push the type to the right.

quad center
To align a line of type in the center of the preset line length, with an equal amount of space on the left and right hand sides.

quadding
The processing of aligning type, as in *quad left*, *quad center* or *quad right*.

quad left
Means the same as *flush left*.

 The Color Resource

quadracolor
A *scanner* function that can produce all four *separations* in four quadrants on one piece of film, in order to reduce output time and film waste.

quadratone
A halftone image created by overprinting four different halftone screens of the same image with different tonal values. See also *duotone* and *tritone*.

quad right
Means the same as *flush right*.

quads
A term used in the color prepress trade to refer to the four separated films, cyan, magenta, yellow and black.

quality control
A complete program of activities, such as customer service, process control, teamwork and sampling with inspection, designed to ensure that the customer is pleased with the final product. The goal is to produce a more than acceptable product the first time by removing the root causes of all process variability.

Quark, Inc.
The Denver, Colorado-based *software* company that publishes *QuarkXPress page makeup software*.

QuarkXPress®
A *software* program that is used for page makeup, published by Quark Inc.

Complete Color Glossary | Q

QuarkXTension™

Any of several modular *software* programs that work only with *QuarkXPress*, extending and expanding its function for a particular task. QuarkXTension *software* runs as if it were part of the original *QuarkXPress* program.

quartertone

Picture tonal values produced with *dot size* percentages of approximately 25 *percent dot area*.

quartz-halogen lamp

A small tungsten light source that is made from a quartz envelope filled with halogen gas and used to illuminate the *original* during *color* scanning—also called a tungsten halogen lamp.

queue

Scanner or *system* functions that are set up to take place sequentially. For example, completed page files can be placed in a queue for overnight output on an *imagesetter*.

QuickDraw™

A type of *page description language* that is part of the Apple *Macintosh operating system*. Output *files* created on the *Macintosh* are interpreted via QuickDraw into *PostScript format*. To the user, this takes place invisibly. Color QuickDraw contains the extensions to QuickDraw supporting *32-bit color*.

ragged
Not *justified*. Text that is set *flush left* can be described as ragged right, or just ragged, and text that is set *flush right* can be described as ragged left.

RAM
Abbreviation for random access memory, the computer's internal memory. RAM contains both *application* programs and information with which the operator is working. When the computer power is shut off, the data in RAM is lost unless it is first saved to a *disk*. The quantity of RAM in a single computer is expressed in *megabytes*—see also *ROM*.

RAM cache
A portion of *RAM* that is designated by the user to hold frequently used information such as printer *font* outlines. Data stored in a RAM cache does not have to be continually read from *disk*. A RAM cache will usually speed computer operations, because computers are able to read data from *RAM* much faster than data from *disk*s.

ramp
See *vignette* and *degradé*.

random access memory
See *RAM*.

random proof
A *color proof* consisting of many images ganged on one *substrate*, randomly positioned with no relation to the final page *imposition*. It is a cost effective way to verify the correctness of completed scans prior to further *stripping* or *color correction* work—also called a scatter proof.

raster
Bitmapped lines of data scanned, processed or output sequentially, line by line. A *raster file* is a *bitmap file*.

raster file
A *file* of data that was input sequentially, *byte* by *byte* and line by line.

raster image processor (RIP)
See *RIP*.

rational screen angles
Screen angles whose tangent is a rational finite number. (In trigonometry a tangent is computed as side opposite over side adjacent.) These angles can be computed in *PostScript* and imaged accurately on *imagesetters*. New screen angling methods, such as *HQS* and Agfa's *Balanced Screening*, calculate an alternate screen angle and frequency for exact placement of dot centers. See also *irrational screen angles*.

RC paper
An abbreviation for resin-coated paper, the photosensitive paper generally used to record the output of typesetters and *imagesetters*. RC paper is more permanent than stabilization paper, another type of typesetting paper.

read-only memory
See *ROM*.

Ready, Set, Go!™
A page makeup program for the *Macintosh*, developed by Manhattan Graphics and distributed in some countries by Letraset. *DesignStudio* replaced Ready,Set,Go! as Letraset's top-of-the-line page makeup software.

real time
Responding to digital signals as they are received. For example, an *image processing* device is said to work in real time when it instantly responds to changes in the *high resolution file* during an operator's manipulations, rather than processing the changes at a later time.

Recommended Specifications for Web-Offset Publications
See *SWOP*.

recorder
See *film recorder*.

red
Describes the *color* of apples and cherries.

1. The portion of the *color* spectrum between orange and russet (a reddish brown).

2. The portion of the *visible spectrum* with the longest wavelengths.

3. In printing, a secondary *color* resulting from *overprinting dots of magenta* and *yellow process color* inks—see *additive color primaries* and *additive color theory*.

red, green and blue

1. The three *primary colors* blended to create the spectrum of colors displayed on a *color monitor*.
2. In printing, *red*, *green* and *blue* are colors made from a combination of *cyan*, *magenta* and *yellow* printing *dots*: *magenta* and *yellow* dots make *red*; *cyan* and *yellow* dots make *green*; *cyan* and *magenta* dots make *blue*.

reflectance

The ratio of *incident light* divided by reflected light. Reflectance is calculated as part of the *density* measurement process. See *density*.

reflection copy

Any *opaque color* artwork submitted for reproduction, as opposed to *transparencies*.

register

Placing two or more images that will *overprint* in exact alignment, one over another, either on film or on a *substrate*. The normal acceptable registration variation is one row of *dots*.

register marks

A cross-hair target that is used to help align film *separations* or to align the printed images on the press sheet.

Register marks

REHM Light Indicator

See *GATF/REHM Light Indicator*.

removable hard disk drive
A unique computer *hard disk* drive, consisting of a chassis, a drive canister and *utility software*, that is used for the quick transfer of large graphic *files*. The entire drive is quickly slid out of its housing and replaced with another, or removed and taken to a different *workstation*, or archived for later use. The large removable hard disks used in some CEPS are also called data shuttles.

rendering
The process of creating three-dimensional shaded objects on a digital graphic *system*.

RenderMan®
A software module developed by Pixar for three-dimensional photorealistic graphics *(modeling)*. MacRenderMan is the name of the Macintosh version of RenderMan.

repeatability
Used to describe *imagesetters* and *film plotters*, a measure of the variance of the absolute positioning of a *dot* from one piece of film to the next. In imagesetting, repeatability is distinguished from *resolution*, which refers to the number of discrete *dots* an *imagesetter* can record within a fixed area.

resolution
A measure of the fineness of the detail that a device can record or output. Resolution is traditionally measured in line pairs per millimeter. Resolution is influenced by the input sample rate and the number of *spots* available in the output recorder. On most *image processing systems*, the operator can determine the number of *pixels* per millimeter in the input scan and, thereby, control the resolution of the image *file*. During the *separation* process, *unsharp masking* enhances the

image resolution, because *unsharp masking* increases the edge *sharpness*.

Desktop publishers typically refer to resolution of input and output devices by their rated *dots per inch (dpi)*. Common resolutions are as follows:

Macintosh monitor	72 dpi
Laser printers	300-600 dpi
Imagesetters	1270-3386 dpi
Desktop scanners	300 to 600 dpi
High-end scanners	up to 10,000 dpi

retouching (digital)
The process of changing image appearance by altering individual *pixels* or groups of *pixels* using a variety of *system* tools, such as an *airbrush* or *pixel clone*. Retouching, which is utilized to correct flaws in an image or to make design changes, usually is done using *full resolution video display*.

reverse
The *negative* of an image, or the process of creating a *negative* of an image—see also *flop*.

rewritable optical disc
A storage medium, shaped like a small phonograph record, which is capable of storing digital images. The *disc* can be read and written on with a *laser*. The data on the *disc* can be read, erased and replaced with new data many times. The data storage capability is very large, usually at least 600 *megabytes*. The *disc* is also very durable and is used for *archival storage*. Also called an erasable optical disc.

RGB
Abbreviation for *red, green, blue*—see *red, green and blue*.

RGB color space
Red, green and blue signals that are used to calculate and store images in *color image processing*. Some *systems* use *cyan, magenta, yellow* and *black color space*.

rhodamine magenta
(ROAD-a-meen) The *magenta* pigment that is used to make *magenta* ink for *process color* printing. This *magenta* ink is nearly ideal as it appears as a bluish magenta. It is higher quality and more expensive than *rubine magenta*.

RIB
Abbreviation for the RenderMan Interface Bytestream, the *file format* that is used by Pixar's *RenderMan* software and proposed as a standard for photorealistic imaging.

RIFF
An acronym for Raster Image File Format, an expanded version of *TIFF* that was developed by Letraset and is used primarily in its *software*, such as ImageStudio and *ColorStudio*. RIFF was designed to handle *CYMK* and *RGB mask* data at a time when *TIFF* could not.

right reading
Reading from left to right, as opposed to wrong reading, reading from right to left.

RIP
Abbreviation for raster image processor, a *software* program or computer that determines what value each *pixel* of a final output page *bitmap* should have based on commands from the *page description language*.

RISC

Abbreviation for Reduced Instruction Set Computing, a type of advanced computer processing chip that operates at speeds far in excess of most *microprocessors*. The Adobe *Emerald RIP* has now been encoded on a RISC chip.

RLE

See *run-length encoding*.

roll-fed imagesetter

See *flatbed imagesetter*.

ROM

An acronym for read-only memory, information that is permanently encased in a computer chip and is not erased when the power is turned off. ROM contains basic instructions which the computer needs to function.

roman

The basic style of upright type within a particular *font* family. Roman type is usually contrasted to *italic* and bold *italic* type.

r[...]

T[...] rmed when two or more-
p[...] at their appropriate angle,
s[...] sette pattern is desirable,
w[...]

rotation

Turning an image by a specified number of degrees, to fit a preset *frame* or design. On a *CEPS* rotation is a very time-consuming function, and often degrades image quality. It is often faster to rescan the image at the new angle.

RS-232
A standard computer connection for communicating with computer *peripherals*. RS-232 is a serial port.

RS-422
A high-speed serial *port*.

RT Screening®
Abbreviation for Rational Tangential screening, a Linotype-Hell patented screening algorithm, which has been licensed to *Adobe* for use in *PostScript (PostScript Level 1,* not *PostScript Level 2).* RT screening uses rational, tangential values for screen angling, such as 18.4° in place of the traditional 15° *screen angle.*

rubberbanding
In *color software*, the ability to grab hold of a *tone* line or *gradation* curve, displayed on the *video monitor*, at any point and pull it to a new position while keeping the two end points fixed.

rubine magenta
(RUU-been) The reddish *magenta* pigment that is used to make a *magenta* ink for *process color* printing. This *magenta* ink has a greater *hue error* and is more reddish than the bluish rhodamine *magenta* process ink. It is less expensive than rhodamine ink and is used for magazine printing. Also called lithol rubine magenta.

Rubylith
A red acetate emulsion on a clear backing; a masking film that is used to make an opening. The film can be cut and stripped from the carrier.

runaround
Type set so that it flows around an illustration to fit its contour or flows around another block of type.

run-length encoding (RLE)
A technique used for *data compression*. During a normal scan, each *pixel* in a *raster* scan is recorded. Using run-length encoding, the only items that must be recorded are the starting *pixel*, the value of the *pixels* and the position of the ending *pixel*. If an area has much redundant data (large areas of the same data), then little information is stored; the data is compressed. However, in very complex image areas little *data compression* is possible.

S

sampling rate
A scanning term that indicates the number of samples taken per inch or millimeter in both scan directions. The *scanner* operator determines the *spot size* to be sampled and the scanner input *resolution*.

sans serif
A typeface without *serifs*.

saturation
The attribute of a *color* that describes its degree of strength and its departure from a gray with the same *lightness*.

scale
To resize an image.

scan data terminal
A black-and-white *monitor* and keyboard that are used as a control terminal for a page makeup console or *peripheral*. Commands, *menus, prompts* and production data are displayed.

scanner
An input device for analyzing and digitizing the content of an *original*.

scanner lamp

The illuminator that is used inside the *scanner* to light the *original* during content analysis. *Quartz-halogen lamps* are the most popular.

scan rate

The number of *lines per inch* or lines per centimeter across the drum that the *scanner* will scan. On most *high-end scanners*, the scan rate is set as a function of the *screen ruling*. The scan rate is usually twice the output *halftone screen ruling* at the final size, which produces four *pixels* per *halftone dot*. *Desktop scanners* usually have a fixed scan rate.

scatter proof

See *random proof*.

Scitex

Scitex Corporation Ltd., established in 1968 in Herzlia B, Israel. The company marketed the first *CEPS* and continues as a major force in *color* electronic prepress technology.

Scitex Handshake

A *file format* that was defined by *Scitex* for translating third-party images and page instructions into a Scitex format.

Scitexing

The incorrect use of a company name as a generic verb to mean making electronic changes to color images. *Scitex* is one supplier of *high-end CEPS* to the graphic arts market.

Scitex users group

See *SGAUA*.

Screen

Screen USA, the U.S. subsidiary of Dainippon Screen Mfg. Co. Ltd., based in Kyoto, Japan. Dainippon Screen, formed in 1943, is one of the largest companies supplying *CEPs* and other image reproduction *systems* to the graphic arts.

screen

1. In a process camera, a sheet of film with *dot* patterns that is placed over the film to be exposed to break the image into *halftone dots*. In digital *systems* stored *gray levels* are converted into *dots* using *screen algorithms* on output.
2. The electronic display surface of a *video monitor* or *CRT*.

screen algorithms

Software that converts *pixels* which are stored as *levels of gray* into *halftone dots* of specific size, shape and *screen angle* for each *process color*. There are a variety of screen algorithms available in digital *systems*; many are patented.

screen angle

The position of the rows of *halftone dots* relative to degrees of a circle. When outputting the four films for reproduction, the *dots* of each *process color* are placed at a distinct and different angle, one to another. Usually, the major strong colors of *cyan, magenta* and *black* are placed at a distance of 30 degrees, although some *software* generates other screen angles.

screen buffer

See *bitmap graphics*.

screen curve

A graph that illustrates the relationship between the stored *gray level* for a *pixel* and the *dot size* that will result on output.

Screen curves are established during *linearization* of an output device—see *tone curve*.

screened negative
See *halftone*.

screened positive
See *halftone*.

screen fonts
Computer files containing the *bitmap* outlines of digitally rendered typefaces for display on a computer *monitor*. Screen fonts offer high fidelity to the final printed output—see also *printer fonts*.

screen frequency
Another name for *screen ruling*.

screening filter
Software that can strip out the *halftone screening* applied to a *file* in an *application* so that an alternate set of *screen algorithms* can be applied.

screen ruling
The number of rows and columns of *dots per inch* of a *halftone screen*. A 150-line *screen*, commonly used for *offset lithography* on coated paper, has 150 rows of *dots* by 150 rows of *dots* or 22,500 *dots* per square inch. The more rows of *dots per inch*, the less apt the observer of the reproduction is to notice the *screen*—also called screen frequency.

screen tint
A *halftone* that contains a uniform *dot size* over the entire area.

SCSI

(SKUZ-ee) An acronym for Small Computer System Interface, an industry communications standard. SCSI is a cabling and *port* specification for connecting multiple *peripherals* in a series to microcomputers.

seamless software

Computer *applications* that can be linked together without any apparent communication problems.

SECAM

Abbreviation for Système Electronique pour Couleur avec Mémoire, the television broadcast standard of 625 lines and 25 frames per second that is used in France, Eastern Europe and the Soviet Union.

secondary colors

See *overprint colors*.

second generation original

See *dupe*.

sector

A computer term for the smallest addressable portion of data storage. The address is an identification (number or name) for the data storage location on a *disk*.

separations

See *color separation*.

serif

The fine-line cross-strokes at the top and bottom of letters of type.

service bureau
An organization that provides output from digital files, usually to a *PostScript imagesetter*. Service bureaus are contrasted to trade shops, which ordinarily use a combination of manual and (non-PostScript) electronic prepress equipment to output and assemble film.

set solid
To set type with *leading* equal to the size of type being used, without any additional space. When a 12 point typeface is set with 12 point *leading* it is set solid, the letter *descenders* of the line above will often appear to touch letter *ascenders* from the line below.

SGAUA
Abbreviation for *Scitex* Graphic Arts Users Association, the *users group* of owners and operators of *Scitex* color *systems*.

SGML
Abbreviation for Standard Generalized Markup Language, a computer programming language that is used to code the attributes of *text files* for subsequent formatting or archiving.

shading
To change the *brightness* or *color* of parts of a graphic image to simulate a three-dimensional depth.

shadow
The darkest part of an image, usually with a density at or near *maximum density*.

shape
An attribute of an image that gives it the three-dimensional appearance. For example, the *cyan separation* gives an apple

its three-dimensional appearance by printing a minimum amount of *cyan* in the front and an increasing amount of *cyan* around the side of the apple.

sharpen

To make *halftone* printing *dots* smaller. Using *negative separations*, sharpening is accomplished with *dot etching*. Over *exposure* will also sharpen the *negative* films. When *positive working plates* are made using *positive transparencies*, sharpening happens automatically and the size of the printing *dots* are reduced by 5%. This sharpening is called negative dot gain.

sharpness

A term that describes the appearance of the image edges in a picture, photograph, video display, *proof* or anywhere images are seen. As the image edges are *sharpened*, more detail will be visible. Unsharp image edges are fuzzy and appear "out of *focus*;" the more clear cut the image edge, the more sharp, "in *focus*," the image is. Edge sharpness can be increased with *unsharp masking*.

sheetfed press

A printing press that feeds sheets of paper, rather than a continuous paper roll or web. Sheets of different sizes can be printed on the same press.

shingling

A technique used in positioning type on book and magazine pages that will be bound by saddle stitching. To compensate for the book thickness, the gutter margin on pages is gradually narrowed from the outside pages to the middle pages of the *signature* so that when the book is trimmed the text is in the proper position in the center pages.

shrink-wrapped software
Packaged *software* that can be purchased through the retail channels—also called *off-the-shelf software*.

signal generator
A device that produces a pulse that causes a *scanner* or an imaging *system* to take a sample of an *original*, compute its correct *pixel* values and store the data for later use. Often, it is a revolving circular *disk* etched with fine lines through which a beam of light passes to fall on a photocell. A pulse is made each time a line passes through the beam.

signal-to-noise ratio
The strength of the wanted signal in relation to the strength of the unwanted signals, which are caused by optical or electronic signal disturbances or static.

signature
A large press sheet in which a group of pages of a publication are positioned in such a way that when printed and folded, they become a section of the publication. Eight-page, sixteen-page and thirty-two page signatures are common.

silhouette
On a *CEPS*, the silhouetting feature allows the operator to isolate just a portion of an image for local correction or retouching. CEPS software can create a silhouette when one image area differs sufficiently in image *density* from the surrounding area.

SIMM
(sim) An acronym for single in-line memory module, *RAM* chips that usually contain one *megabyte* of *RAM*.

single sheet color proof
A *proof* made by placing layers of *toners*, dyes or pigments on a single *substrate* without the intermediate thin membrane carrier sheets as used for an *overlay color proof*. Some common types of single sheet *off-press proofs* are Color-Art, *Cromalin*, *Matchprint*, Pressmatch and Signature.

skeleton black
A *black separation* that adds detail and *contrast* only in the darkest areas of a four-*color* reproduction from the *quartertones* to the *shadows*.

skinnies
See *fatties and skinnies*.

slot
A part of a computer where an extra circuit board can be inserted to extend the function of the machine. The *Macintosh* and *IBM* microcomputer families each have multiple slots, often six or eight.

slur
The smearing of the *halftone dots* on the press sheet in the direction of travel through a *lithographic* press. This makes the *dots* look like comets and causes *dot gain*.

small caps
A type style created from the capital letters of the *roman* face, at a size about 75% of the full type size.

SNAP
(snap) An acronym for the Specification for Non-Heat Advertising Printing, a set of production specifications developed for uncoated and newsprint paper for *separations*, *proofing*

and printing in the United States—see *SWOP*, *MAC* and *FIPP*.

sneaker net

Moving data from one device to another nonelectronically. A person using foot power or "wearing sneakers" physically picks up the *disk* and takes it to another device. The speed *(bandwidth)* of this method is usually fast, so it is particularly effective for larger data files.

soft dot

A *halftone dot* with a weak fringe *density* surrounding a solid core. A dot formed using a contact *screen* will have dot fringe. The fringe will not hold back light during *plate exposure*, which results in an improper sized *dot*—see *hard dot*.

soft proof

A *color* video display that simulates the expected visual printed result of stored *pixel* data. Predictions about the appearance of the printed image can be made based on the image on the *screen*.

software

Sets of instructions that are used to control the operation of computer hardware.

spectral energy distribution

Energy output from a light source, expressed in *nanometers*.

spectrophotometer

A device that very accurately measures a *color* sample at many wavelengths and plots the reflectance at each wavelength on a spectrophotometric curve. It can also compute colorimetric attributes.

specular highlight
A direct reflection of a light source in a shiny surface that has no detail and is printed with no *dot*. Not to be confused with *diffuse highlight*, the whitest neutral area of an *original* or reproduction that contains detail and will be reproduced with the smallest printable *dot*. Specular highlight is also called drop-out highlight.

spindle
See *lead screw*.

spot
The smallest diameter of light that a *scanner* can detect or an *imagesetter* or *film plotter* can expose. Spot should not be confused with *dot*, which is the individual element of a *halftone*.

spot color
Localized *color* assigned to a graphic or block of text, prepared with a *color break* and printed without the use of *color separations*. Usually *process color* is not assigned to the spot color areas. Spot color is frequently printed with nonprocess color inks, although process inks can be used as well.

spot size
The physical size of a recording or scanning *spot*. The smaller the spot size, the higher the *resolution*.

spread
A pair of facing sequential pages.

spreads and chokes
Spreads and chokes refers to a prepress function that compensates for printing press misregistration. A choke is the slight size reduction of the opening within an image into

which another image will print; a *spread* is the slight size increase of the inserted image. Making the opening smaller and the inserted image larger causes the filling image to slightly overlap the opening's edges and prevents a white edge at the junction of the two images that might be apparent after printing—also called *fatties and skinnies*. Chokes and spreads produce image *trapping*.

stair steps
See *jaggies*.

standalone
A hardware device that is physically separate from other devices with which it operates. For example, a standalone *RIP* is housed in a unit separate from the *imagesetter* it controls.

Standard Color References, IPA
See *IPA Standard Color References*.

Standard Offset Color Bar, GATF
A color control guide that is printed on the edge of a press sheet, consisting of assorted solids, *tints*, overprints, *slur* and *sharpness* guides, and used in *offset lithography* to control *proofing* and printing.

standard platform
Any commonly available computer or *workstation*, such as a *Macintosh*, an IBM-PC, an IBM-compatible or a *UNIX workstation*.

standard viewing conditions
The requirements for the *environment* that were established by the *ANSI* Committee for evaluating *transparencies* or reflection prints. Simply stated: standard viewing conditions are comprised of a *neutral gray* surround, illumination by a

light source of 5000K, and a light level of approximately 200 *foot candles*. Large *format transparencies* should be encircled by 2-4 inches of white surround, and should not be viewed with a dark surround.

starting point
A scanning term that indicates the location on the *tone* scale at which a particular function of a *scanner* kicks in. For example, the starting point is defined for *UCR* or for a *highlight limiter*.

Status "T"
A set of specifications that defines a *densitometer's* total spectral response characteristics according to *ANSI* PH 2.18 (1984). *Densitometers* are manufactured to the Status "T" specification. Proper calibration of a Status "T" *densitometer* requires the *T-Ref*.

stepping motors
A type of electric motor that moves a very precise distance at the command of a computer. For example, a stepping motor drives a *drum scanner's lead screw*.

step tablet
A narrow strip of film consisting of an orderly variable progression of increasing differences of *neutral gray densities* ranging from clear film to *maximum density*—also called a step wedge. Step tablets are used to control *plate* exposures—see also *gray scale*.

step wedge
See *step tablet*.

stet
When a correction has been noted on a proof, but is no longer required, "stet" indicates "ignore the correction," or "leave as is."

still video (SV)
A video recording format that uses an *electronic camera* to record a single frame analog image on a small floppy *disk*. Either 50 field images or 25 frame images are stored.

still video camera
See *still video* and *electronic camera*.

stripping
The process of assembling and arranging all of the film intermediates on a goldenrod or polyester carrier in their correct page position and *imposition* so that *printing plates* can be made. In electronic *stripping*, the page elements are appropriately positioned on the digital page layout.

stroking
In graphic software, a process of building lines of varying thicknesses around objects, usually to create *spreads* for *trapping*.

style sheet
A series of typographic *formats* stored so that they can be quickly applied to blocks of text. Style sheets may also include some graphic information, such as rules and colors. Using style sheets is easier than manually formatting large sections of text.

stylus
A pen shaped pointer that is connected to a computer and used on a *digitizing tablet* to position images and locate functions on a *menu*.

subscripts
See *inferior characters*.

substrate
Any material that can be printed on, such as paper, film, plastic, fabric, cellophane or steel.

subtractive color primaries
The process ink colors, *cyan, magenta* and *yellow*. Each absorbs or subtracts its complimentary *color, red, green* or *blue*, from the light reflecting off the paper. *Cyan, magenta* and *yellow* printed together produce a *three-color black* which is slightly brownish because of the unwanted *hue error* of the inks.

subtractive color theory
The principle surrounding the printing of *cyan, magenta* and *yellow* inks on paper for the purpose of absorbing portions of the *red, green and blue* light that is illuminating the surface, to prevent it from reflecting back to the observer's eye. Different combinations of *cyan, magenta* and *yellow* are what create the appearance of the *visible spectrum* on the paper.

supercell
In digital *halftone screening*, a supercell is an aggregate of halftone dots which are manipulated as a single group.

superior characters
Type that is set above a line in a size generally 20% smaller than the other text for example, x^2. Also called superscripts.

SV

Abbreviation for *still video*.

SVGA

Abbreviation for Super *VGA*, a video card that extends *VGA resolution* to 1024 x 768 *pixels*, with 256 simultaneous display colors.

S-VHS

A higher quality variant on the *VHS* video *format* that uses higher *luminance*.

swatch book

Color patches of many combinations of *process colors* or special ink colors that are printed on paper, bound into a book and used to identify or specify a given *color*. See also *color matching system*.

swatching out

An evaluation technique that is used mainly in *gravure* printing to verify that the films and *proofs* furnished will in fact produce the expected results for a given printing *system*. The *color proofs* are compared to swatches with values of *density* and *dot area* already known to be achievable with the printing *system*.

SWOP

Abbreviation for the Recommended Specifications for Web-Offset Publications, a set of specifications for *color separation* films and *color proofing* that is used to insure consistency of *color* printed appearance between different publications. The SWOP standard concentrates on evaluating the accuracy of the *color proof* and the ability of the printer (a person) to match the *proof*. SWOP was developed in the United States for magazine production as the result of a joint committee

of the American Association of Advertising Agencies (*AAAA*), American Business Press (ABP), American Photoplatemakers Association (APA), Graphic Arts Technical Foundation (*GATF*), Magazine Publishers Association (MPA), National Association of Printing Ink Manufacturers (NAPIM) and International Prepress Association *(IPA)*. Available from *AAAA*, ABP and MPA—see *MAC*, *FIPP* and *SNAP*.

SWOP inks
A set of process inks that meet the *SWOP* specifications.

SWOP inspection report
A form that is filled out when a set of *separation* films and *proofs* are analyzed to determine if they meet the *SWOP* specifications.

SYLK
Abbreviation for SYmbolic LinK, a *file format* developed by Microsoft to define data and chart *formats*. SYLK is used primarily with spreadsheet *software*, although the *format* can be *imported* into some graphics *applications*.

syntax
The specific order of computer commands required in a computer *system*.

system
An assemblage of hardware and *software* dedicated to performing a specific task, such as a *color* electronic prepress system *(CEPS)*, a *desktop publishing system*, an *electronic publishing system*, a *management information system (MIS)* or a page makeup system—see *turnkey system*.

System 7
Version number 7 of the Apple *Macintosh operating system*. System 7 is notable for its ability to share data between *applications* and between users on a *network*, and for its ability to address 128 *MB* of *RAM*.

system architecture
All of the hardware and *software* that is assembled into a working unit to perform a range of tasks.

System Brunner
A *color* control method developed by Felix Brunner for the purpose of *color* optimization, as well as *proofing* and printing control, focusing on the influence and control of *dot gain*.

system integration
The actual configuring and connecting of different hardware and *software* components into a complete electronic page makeup *system*.

system integrator
Any company that specializes in assembling other manufacturers' hardware and *software* components into harmonized production units.

T-1 line
A communication *system* with a *bandwidth* capable of sending 1.57 megabits per second.

tack
The amount of stickiness in printing inks that makes them print while minimizing dot gain.

tag
In page composition *systems*, a notation that defines each classification of text in a publication, such as the title, subtitles and body text. Typographic styles can then be assigned to each tag. This makes it possible for a designer to change just a single tag and experiment with type changes throughout a publication.

tape reader
A device that can read magnetic or paper tape and is used to input data into a *system*.

TARGA
An *RGB 24-bit color* graphics *file format* that was designed for *MS-DOS* computers. TARGA includes *NTSC* video support.

TekHVC
A *color* data standard proposed by Tektronics that is a variation of *CIELUV*.

template
A temporary background image or shape on the computer *monitor* into which text and artwork are inserted. A page-layout template is similar to the nonreproducible blue lines that a graphic designer manually draws on a board as the guide for positioning elements on a *mechanical*. When the *mechanical* is photographed, the blue lines are not recorded, neither is the computer template printed when documents are output.

terabyte
One trillion *bytes*.

tertiary colors
Colors that are made up with portions of all three process ink pigments.

text file
A *file* containing text saved in *ASCII format*. Text files are easily communicated between *systems* and programs because *ASCII-format* text can be read by nearly all computer *software*. However, text files do not contain all of the detailed formatting contained in the proprietary formats of *word processing programs*.

TGA
Abbreviation for the *TARGA* graphic file format.

thermal transfer printer
A *color* digital printer using colored waxes that are heat-transferred and fused to special coated papers. The inexpensive

color desktop printers from vendors such as QMS, Océ, Seiko and Tektronix, use thermal transfer processes. Most thermal transfer printers can image *PostScript* files.

thin space
A measure of space placed between *characters* equal to ¼ to ⅓ of an *em*.

three-color black
A *neutral gray* made up of *cyan, magenta* and *yellow* pigments in correct percentages and ink *densities*. However, by *overprinting* the *process color* inks in equal *dot sizes*, it appears brown, rather than gray, because of the ink impurities.

three-quartertone
Picture tonal values produced with *dot size* percentages of approximately 75 *percent dot area*.

TIFF
An acronym for Tag Image File Format, a standard *file format* that was developed by *Aldus Corporation* for *bitmap* or *raster graphics*, usually for scanned images. TIFF can handle a variety of image data, from 8-bit black-and-white images, to *24-bit color RGB* or *CYMK* images. *Vector graphics* are usually stored in *PICT* or *EPS format*.

tile
The process of breaking an image down into smaller sections for output when processing a *file* larger than the maximum imaging area of an output device.

tint
1. A *halftone* of a specified *dot* percentage, less than 100%.
2. A variant of a *color* that is created by mixing a defined amount of white with the basic *color*.

3. *Flat tints* and *spot colors* are often called tints.

toggle back and forth

To alternately switch from one *file* to another *file* or one display to another display for the purpose of comparing a before and after image on a *monitor*, such as during image manipulation on a *color workstation*.

tonal range

The maximum range of *tones* in an *original* or reproduction—see *density range*.

tone

The character of a *color*, its quality or lightness. Verb tense, to tone, means to change or modify a *color*.

tone compression

The reduction of an *original's tonal range* to a *tonal range* achievable through the reproduction process.

tone correction

See *gamma correction*.

tone curve

The relationship between each *original density* and each reproduction *density* that can be shown on the *scanner dot area* meter or plotted on a graph. During *scanner* setup, the tone curve is adjusted with the aid of the *dot area* reading displayed on the *scanner's* meter. *Screen curves,* on the other hand, show the relationships of either the *original densities* or the stored *pixel* gray values, and the *halftone screen* values.

tone reproduction

The tonal relationships between all of the elements of a reproduction, the intermediate films and the *original*. A

graphic analysis can be plotted to study the *contrast* of the reproduction. A four-quadrant plot showing all the tonal values is called a Jones Diagram. Tone reproduction, *gamma, contrast* and *gradation* may mean almost the same thing depending with whom you are talking.

toner
The dyes or pigments applied to a *substrate* to create an image.

toner cartridge
In a *laser printer*, the user-installable, removable, plastic cartridge holding the *toner* particles that create the image on a *substrate*.

toning
A printing defect that is caused by ink printing where it should not print. Toning is the weak *color* in nonimage areas of the reproduction that gives the visual appearance of more *color* everywhere.

toolbox
A visual *palette* on a computer display that contains a variety of frequently used *drawing* and image modification devices. Most *color* imaging *software* includes a toolbox.

total density
The total amount of printing *dot* in a given area on a press sheet or on *separation* films. The term is misleading, because the total amount of printing *dot* should not be specified as a *density*. The correct term is *total printing dot*.

total printing dot
The total amount of printing *dot* in a given area on a press sheet or on *halftone separation* films.

track

1. A portion of a *disk* surface that is used to organize the information stored. When the *disk* is initialized, the *operating system* separates the *disk* surface into circular tracks and divides each track into *sectors*.
2. The name given to each complete computer circuit on a *CEPS*. Usually, only one function can be happening on each track at one time.

track ball

A computer control knob in the shape of a sphere used to move images around in two dimensions. A track ball acts similarly to a *joy stick*.

tracking

The process of reducing the space between *characters* by a consistent amount, as opposed to *kerning*, where space between two letters is separately adjusted.

traditional color angles

The screen angles used most often in color separation, considered to be optimal for reducing moiré patterns—yellow at 0°, cyan at 15°, black at 45° and magenta at 75°. If the separation contains a lot of magenta and not too much black, the magenta and black angles are sometimes swapped.

tranny

Slang term for *transparency* that is used in the United Kingdom, Australia and New Zealand.

transformation algorithm

An equation that defines a transfer from one input/output relationship for a set of conditions to another *system* or *peripheral*. For example, a transformation *algorithm* could be used to represent the amount of *red* signal, *green* signal

and/or *blue* signal needed on a *video monitor* to simulate any printed value of *cyan, magenta* or *yellow* ink. The alternative to a transformation algorithm is a *look-up table*.

transmission rate
The amount of data that can be transmitted in a given period of time, specified in *bits* per second *(bps)*. Specified in cycles per second, transmission rate refers to the *bandwidth* carrier.

transmittance
The ratio of *incident light* divided into transmitted light. Transmittance is calculated as part of the *density* measurement process. See *density*.

transparency
The photographic *color positive* film that represents a *color image*, such as Kodachrome, Ektachrome or Fuji Chrome—also called by the slang terms, *tranny* and *chrome*. Standard sizes are 35mm, 2¼" x 2½", 4" x 5" or 8" x 10". Transparencies are the preferred *original* for *color scanning* because film offers higher *resolution* than photographic print material.

transparency viewer
A small box containing a 5000K light that is used for viewing *transparencies*.

transparency viewing lamp
A small light source, larger than the scanning *spot*, that is located on a *color drum scanner* and used to view a *transparency* mounted on the input cylinder. This light is usually a small *5000K* fluorescent lamp.

transparent
Capable of transmitting light—the opposite of *opaque*.

transparent software and transparent functions

Operations that take place automatically when certain other functions are used by a computer operator. These operations are not seen and, therefore, are transparent or invisible to the operator.

transponder

A radio *frequency* repeater that can receive a radio signal and retransmit the signal to other recorders. Often it is found on satellites and ground stations.

transputer

A *microprocessor* that is part of a larger array of *microprocessors*; each simultaneously does a portion of the necessary calculations.

trapping

1. Adjoining colors overlapped by a row or two of *halftone dots* to minimize the effect of misregister. Without trapping a fine white line would appear between two *color* images during the printing of *process color*.
2. The ability of an ink to print onto another ink. One hundred percent trapping occurs when the same amount of ink will print on the first ink as it does on the unprinted *substrate*. More frequently undertrapping occurs, because one wet ink will not adhere properly when applied to another wet layer of ink. Ink trapping is controlled by adjusting tack.

T-Ref

A Graphic Communications Association *(GCA)* standard reflection *densitometer color reference* that is used to calibrate a *Status "T" densitometer*. The T-Ref is made by printing *SWOP inks* onto paper at the appropriate *densities* and calibrated with the use of a *spectrophotometer*. Accurately using the T-Ref

calibration plaque improves inter-instrument agreement of *densitometers*.

tristimulus values
The *red, green* and *blue* readings acquired when measuring a *color* with *red, green* and *blue filters* using a *color* measurement instrument. Tristimulus values are expressed in capital letters, such as LUV in *CIELUV*.

tritone
A halftone image created by overprinting three different halftone screens of the same image with different tonal values. See also *duotone* and *quadratone*.

TrueType™
A *font format* created by Microsoft and *Apple Computer*. TrueType is intended to replace Adobe *PostScript fonts*, mainly on lower-cost publishing *systems*.

TRUMATCH™
A *color* matching system that utilizes an array of printed *process color tint* swatches. TRUMATCH is used to specify *process color tint* values.

tungsten halogen lamp
See *quartz-halogen lamp*.

turnkey system
A publishing *system* that is ready to operate without requiring any additional hardware or *software*.

type family
The set of associated typefaces that usually includes *roman*, bold, *italic* and bold *italic* styles, as well as sometimes including additional *weights* such as light or *condensed*.

Type 1 fonts

PostScript Bezier outline *format fonts* with special *encryption* for compactness and improved quality on low-*resolution* output devices—see *Bezier curves*.

Type 3 fonts

PostScript Bezier outline *format fonts* without the *encryption* that characterizes *Type 1 fonts*. Now that the Adobe *Type 1 font* specifications are widely understood, Type 3 fonts are infrequently used—see *Bezier curves*.

UCA
See *undercolor addition*.

UCR
Abbreviation for undercolor removal. The technique of reducing the *cyan, magenta* and *yellow* content in *neutral gray* shadow areas of a reproduction and replacing them with *black* ink so that the reproduction will appear normal but will use less *process color* ink.

UGRA Wedge
(OO-graa wedge) Special film strip control device that is about 1 inch by 6 inches in size and contains test targets for controlling accurate film *exposures* on contacts and *printing plates*. UGRA is a graphic arts research association located in Switzerland.

undercolor addition (UCA)
A technique that is used to add *cyan, magenta* and *yellow* printing *dots* in dark neutral areas of the reproduction.

undercolor removal
See *UCR*.

undercorrection

Insufficient *color correction* made to compensate for the *hue errors* of process inks. The result is a reproduction that appears to have one or all *hues* contaminated with the wrong *color*. The reproduction will print too dark; the colors will appear too warm or dirty. Undercorrection is the opposite of *overcorrection*.

uninterruptible power supply (UPS)

A device that automatically powers a computer without delay when the main power supply fails. The reserve power may be continuous, or it may be only enough protection to allow for an orderly shutdown to avoid data loss.

UNIX®

A high-power *operating system* that was designed by AT&T in the early 1970s. The key difference between UNIX, *MS-DOS* and the *Macintosh operating system* is that UNIX has built-in support for *multitasking*. There are several variations of UNIX in use on *workstations* from suppliers, such as Sun, NeXT and Hewlett-Packard.

unsharp mask

A fuzzy, low *contrast* photographic *negative* that is made from a *transparency* and placed over the *transparency* when *separation negatives* are exposed. The *mask* alters the light exposing the *separations* to *color* correct for the *hue errors* of the inks. Being unsharp, the *mask* also exaggerates (enhances) the edges of images, producing more detail.

unsharp masking (USM)

An edge enhancement process accomplished with one of three techniques, one photographic method and two electronic methods, optical and digital. Regardless of the method used, the result of USM is the same—all edges in

the image are exaggerated, which produces more detail in the reproduction. The photographic unsharp masking method uses an *unsharp mask* that also compresses the *tones* and *color* corrects. Optical unsharp masking is done on a *scanner* by determining where edges occur. The *original* is analyzed through separation *filters* and through both the small signal aperture and the large USM aperture.

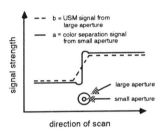

Illustration of corrected signal

The two signals are compared to produce a *peaking* signal that generates the enhanced edges. Digital unsharp masking is done after the scanning has been completed. Adjoining *pixel* values of digitally stored images are evaluated to locate the edges. When an edge is detected, the *software* exaggerates the edges by altering the value in the two adjoining *pixels* in opposite directions, thereby increasing the edge *contrast*. Unlike photographic USM, electronic USM does not *color* correct or compress the *tones*—see *area mask, outline mask* and *unsharp mask*.

unwanted colors
Process colors that should not be present in certain areas of a reproduction, such as *cyan* in *yellows* or *magenta* in *greens*.

uplink
An *earth station* that can transmit a signal to a satellite above the earth.

upload
To send a data *file* to a larger computer, *file server* or *bulletin board*.

UPS
See *uninterruptible power supply*.

user-friendly
A term that is used very loosely to describe computer *operating systems* and *applications* that are easy to learn and use. Because of its graphical user *interface (GUI)*, the *Macintosh operating system* is widely considered to be more user-friendly than *MS-DOS*.

user interface
See *interface*.

users group
A club or association whose members share an interest in using a specific computer, *application* or *system*, such as a *Macintosh*, *QuarkXPress* or *Scitex systems*.

USM
See *unsharp masking (USM)*.

utility
A type of *software* that is used to do a specific small job, such as count the words in a *file*, or run a small calculator or clock. Good utilities are invaluable to enhance the basic computer *system*.

u,v,L
A *color space* used by Eastman Kodak in its Designmaster and Prophecy systems.

value
A measure of the *color* lightness or darkness attribute rated 0-10 in the Munsell system.

vaporware
A term referring sarcastically to a *software* program that has been announced but never shipped.

VAX
Acronym for Virtual Address Extension, a family of *minicomputers* marketed by Digital Equipment Corporation (DEC). Most VAX computers are used for data processing, not for graphics, although some are used for image archiving and image database management.

VDT
Abbreviation for video display tube, a *color* or black-and-white *monitor* that is used to display text, graphic and picture data.

vector
A line between two points.

vector file

A *file* created on a page makeup *system* containing page design commands that specify the start, the end, and the length of each line. A vector file might also specify geometric shapes and their dimensions, e.g. a circle is defined by three pieces of discrete data, the circle center point x, y location and the circle radius.

vector graphics

Drawing software that processes drawings and illustrations as a series of points and connections, which are compact for a computer to store and manipulate. Most *drawing* and illustration *software* employs vector graphics. Vector graphics are usually stored in *PICT* or *EPS format*. Early computer graphics employed mainly *bitmapped* drawings, where every single point had to be defined. *Bitmapping* can be more precise than vector *drawing*, but it is much slower and demands much more computer memory.

vehicle (ink)

The solvent of an ink into which the pigment is added.

Velox

A black-and-white glossy photographic print of line and *halftone* images that is used as a *proof* of *negatives* to show how the printed reproduction will appear.

Ventura Publisher™

A *software* program that is used for page makeup. Ventura Publisher is a Xerox Corporation product and is available for both *Macintosh*, IBM and IBM-compatible computers.

vertical justification

The process of aligning a block of text vertically within a preset area.

VGA

Abbreviation for Video Graphics Array, a medium-*resolution* video card that was developed for *IBM's* PS/2 line of computers, and now is widely used for IBM-PC and compatible computers. VGA displays 256 colors at a 640 *pixels* x 480 *pixels resolution*.

VHS

The most popular North American home video *format* used on ½ inch magnetic tapes.

video analyzer

An electronic viewing device that simulates the printed result by displaying the *transparency* or the *separations* on a *color monitor* for the purpose of viewing and correcting the appearance.

video camera

A device that captures a scene as electronic information.

video disc

See *optical disc*.

video display tube

See *VDT*.

video monitor

See *VDT*.

video scanning

Electronically records an image as *analog data* and converts the video signal to a digital image for display and further image processing.

The Color Resource

viewfile

A subsample, *low resolution file* of a digital image *high resolution file* that is usually created so that *page layout software* can operate more efficiently while still maintaining a viewable image. Often viewfiles are created at the *resolution* of the computer *monitor*.

vignette

A *gradation* change of only one *color* that varies only in strength *(brightness)* or *lightness*. In some cases, a vignette is created at the edge of an existing image, causing the *color* to fade to white over a specified area. Vignette does not change in *hue* while *degradé* changes in strength and *hue*.

V.I.P.™

Abbreviation for Visionary Interpreter for *PostScript*, a *Scitex* proprietary *desktop-to-prepress system* that allows any *PostScript file* to be interpreted into a *Scitex CEPS*.

virtual memory

A portion of a *hard disk* that is allocated for working files to supplement a computer's *RAM*.

visible spectrum

Light that is visible to the human eye and is perceived as different colors. The visible spectrum is the 400 to 700 *nanometer* portion of the electromagnetic spectrum, which is the entire range of wavelengths from *gamma* rays to the longest radio waves. Infrared wavelengths are longer, and ultraviolet wavelengths are shorter than the visible spectrum—see *white light*.

Visionary™

A *Scitex* proprietary *desktop-to-prepress system* that uses a *Macintosh* and a version of *QuarkXPress software* to send *page geometry* information to a *Scitex CEPS*.

voice grade line

A communications line that is used for normal telephone conversations with a nominal *bandwidth* of four kilohertz capable of transmitting up to 19.2 *kilobits* of information per second.

web offset
A printing *lithographic* process that prints on paper from a continuous roll and delivers onto another roll or as folded *signatures*.

web press
A printing press that prints on paper from a continuous roll and delivers onto another roll or as folded *signatures*. *Lithographic*, *gravure*, flexographic and *letterpress* printing processes can all use web presses.

weight
The comparative amount of blackness of a type style. Typefaces of differing weights have names such as light, semi, bold or ultra bold.

white alignment
A procedure to calibrate a *color scanner* before scanning; the scanning lamp is calibrated through the scanning cylinder to balance the *red, green* and *blue* signals on a *step tablet highlight* or clear *scanner* drum. When white alignment is used on a *transparency* or a reflection *original highlight* to remove its *color cast*, it is described as white out.

white light

Illumination, such as sunlight, composed of all the colors of light in the *visible spectrum*. The *visible spectrum* components can be seen in a rainbow or in sunlight shining through a prism.

white out

See *white alignment*.

wide-area network

A communication *network* suitable for transmitting picture files over long distances. This might be accomplished with microwave, radio waves or telephone lines. The user might own, lease or rent the equipment, or lease or rent time on the *network*.

wideband

An adjective, sometimes referred to as broadband.
1. Describes a *densitometer color filter* response that has an optical opening width in *nanometers* similar to separation *filters*. The *filter* response transmits the wide band of the *visible spectrum*. *Narrowband filters* are sometimes used with *densitometers* to increase their sensitivity to certain variations.
2. Describes frequencies and electronic signals of communication circuits.

widow

In typography, the last line of a paragraph that is forced to become the first line of a new page. Also refers to one or two words on a line by themselves.

Winchester drive

A type of *hard disk* drive that is used for magnetic computer storage on *color* page makeup *systems*. Its storage capacity may be approximately 300, 600 or 900 *megabytes*.

window

A part of the computer *screen* that is used to show a message or picture. Windows can be opened and closed, resized and reorganized.

Windows™

Special *system software* that was created by Microsoft to operate on IBM-style computers, which run with *MS-DOS*. Microsoft Windows lets the computer work more like a *Macintosh*, using *icons*, *windows* and pull-down *menus*. Windows 3.0 is the latest and most popular version of Microsoft Windows.

word processing programs

Applications that *format* text.

wordspace

The amount of space between words, versus *letterspace*, the space between the letters in a word.

workstation

A powerful small computer that runs the *UNIX operating system*. Workstations are generally more powerful than personal computers, such as the IBM-PC and the *Macintosh*, and less powerful than *minicomputers*, such as the DEC *VAX system*.

WORM

An acronym for write-once, read-many times. A WORM *optical disc* can only be imaged once and the data cannot be erased. There is no limit to the number of times the data can be read.

wraparound

Means the same as *runaround*.

Wratten gelatin filter

A thin colored plastic that is optically pure and used to separate colors in photographic systems. The Wratten filter number specifies the *filter color*. To make *color separations*, the most commonly used are #25, red; #58, green and #47B, blue.

write-once, read-many

See *WORM*.

wrong reading

Reading from right to left, as versus right reading, from left to right.

WYSIMOLWYG

An acronym for "what you see is more-or-less what you get." In most digital publishing *systems*, what you see on the *monitor* is rarely exactly what you get on output, and several observers felt that *WYSIWYG* was an overstatement of the precision of *desktop publishing*.

WYSINWYG

An acronym for "what you see is not what you get," a play on *WYSIWYG*.

WYSIWYG

An acronym for "what you see is what you get." The term is used in several situations, such as when a *color proof* is shown to the customer. The person presenting the *proof* assures the customer that what you see is what the press will produce. Or, in *desktop publishing*, the term is used to refer to the ability of *desktop* computers to display on their *monitor*s a reasonable representation of what will appear on the printed page.

X-Z

xenon lamp
A high pressure light source that is used to expose film on some *color scanners*. Xenon lamps were also a source of *white light* for *original copy* evaluation on some early *color scanners*.

XGA
A post-*VGA*, IBM-supported, video graphics standard offering 1,024 pixels x 768 *pixels resolution* with 256 colors.

XPress®
See *QuarkXPress*.

XTension™
See *extension* and *QuarkXTension*.

X Windows™
A standard *GUI* for *UNIX*, widely supported by *workstation* vendors.

yellow
1. The subtractive *primary color* that appears yellow and absorbs *blue* light.
2. One of the *four-color process* inks, made from the organic pigment, diarylide yellow, formerly called benzidine yellow.

YMCK
Abbreviation for *yellow, magenta, cyan* and *black*—see *CMYK*.

Product List

4Cast (DuPont) a direct digital color proofing printer
ACS (Associated Color Systems) a computerized color matching system
Agfaproof (Agfa) a single-sheet color proof
Approval (Kodak) a direct digital color proof
Cache (EFI) color retouching software
Cibachrome (Ilford) a color photographic print paper
CLS (DuPont-Crosfield Lightspeed) abbreviation for (Lightspeed) Color Layout System
ColorArt (Fuji) a single-sheet color proof
Colorcurve (Colorcurve) a color matching system
ColorGetter (Optronics) a color drum scanner for desktop computers
Color-Key (3M) an overlay color proofing product
ColorStudio (Letraset) color retouching and separation software for the Macintosh
CorelDRAW (Corel) vector drawing software for the PC
Cromacheck (DuPont) an overlay color proof
Cromalin (DuPont) a single-sheet color proof
DesignStudio (Letraset) page makeup software
Digital Matchprint (3M) a direct digital color proof
Doublecheck (Kodak) a photographic position proof
Emerald RIP (Adobe) a RISC RIP
Exabyte (Exabyte) a magnetic tape data storage and archiving system
Fiery (EFI) software to calibrate color proofers
Flamenco (Anaya) patented color halftone screening method using identical screen angles

Focoltone (Focaltone) a color matching system

FrameMaker (Frame Technology Corporation) page layout software

Freehand (Aldus) vector illustration software

Handshake (Scitex) a communication link with Scitex CEPS

Illustrator (Adobe) vector illustration software

Imprint (DuPont) a photographic position proof

Inkjet Prediction Proofer (Stork) a direct digital color proof

Linotronic (Linotype-Hell) model name for a family of imagesetters which includes the L330 and L530

Lumena (Time Arts) color retouching software for the PC

MacDraw (Claris Corporation) vector drawing software for the Macintosh

Matchprint (3M) a single-sheet color proof

MultiAd Creator (Multi-Ad Services) single-page design software

PageMaker (Aldus) page makeup software

Pantone Matching System (Pantone) a color matching system

Photoshop (Adobe) color retouching and separation software

PrePrint (Aldus) color separation software for the Macintosh

Pressmatch (Hoechst) single-sheet color proofing

Prophecy (Kodak) midrange color system

QuarkXPress (Quark) page makeup software

Ready,Set,Go! (Letraset) page makeup software

Recoprint (Agfa) a photographic position proof

RIPLINK (Screaming Technology) a hardware and software system to link desktop computers to a Hell or Scitex CEPS

ScriptMaster (Hell) a hardware and software system to link desktop computers to Hell CEPS

Complete Color Glossary

SelectSet 5000 (Agfa) an imagesetter
Signature (Kodak) a direct digital color proof
SpectreScan (Prepress Technologies) color scanning software
Stork Color Proofing (Stork) a single-sheet color proof
StudioLink (DuPont-Crosfield) software to link DTP to a CEPS
System Brunner (System Brunner USA) a color control system for printing and proofing
TRUMATCH (TRUMATCH) a color matching system
Ventura Publisher (Ventura) page makeup software
VIP (Scitex) a desktop to Scitex CEPS link
Visionary (Scitex) a desktop to Scitex CEPS link
Word (Microsoft) a word processing program

Note: Many software products use the company name in their official trade name, as in Adobe Illustrator *or* QuarkXPress.

For a complete listing of all available color software and hardware products refer to the book, ***The Color Resource Color Desktop Publishing Product Annual,*** edited by Thad McIlroy and Maury Zeff. This database of over 450 color publishing products for the PostScript environment is published by The Color Resource.

Bibliography

For a complete listing of all available books on color publishing, please refer to The Color Resource publication, ***The Color Resource Color Training Resources Annual,*** edited by Miles Southworth and Thad McIlroy.

Brown, Bruce. *Browns Index to Photocomposition Typography*. Somerset (UK): Greenwood Publishing, 1983.

Downing, Douglas, and Michael Covington. *Dictionary of Computer Terms*, 2nd ed. Hauppage: Barron's Educational Series, 1989.

Freedman, Alan. *The Computer Glossary*, 5th ed. New York: AMACOM, 1991.

Garland, Ken. *Graphics, Design & Printing Terms*. New York: Design Press, 1989.

Latham, Roy. *The Dictionary of Computer Graphics Technology and Applications*. New York: Springer-Verlag New York, Inc., 1991.

Mintz, Patricia Barnes. *Dictionary of Graphic Arts Terms*. New York: Van Nostrand Reinhold, 1981.

Pfaffenberger, Bryan. *Que's Computer User's Dictionary*. Carmel, IN: Que Corporation, 1990.

Romano, Frank J. *The TypEncyclopedia*. New York: R.R. Bowker, 1984.

Scitex Graphic Arts Users Association. *Glossary*. Bedford, MA: Scitex America, 1990.

Sinclair, Ian R. *The HarperCollins Dictionary of Computer Terms*. New York: HarperCollins Publishers, 1991.

Typographers International Association. *TIA's Glossary of Typographic & Computer Terminology*, 2nd ed. Washington, DC: Typographers International Association, 1989.

Vince, John. *The Language of Computer Graphics*. New York: Van Nostrand Reinhold, 1990.

About the Authors

Miles Southworth
Miles Southworth is vice-president of The Color Resource and a leading authority on color printing technology. He is the Roger K. Fawcett Distinguished Professor of Publications Color Management at the School of Printing Management and Sciences (SPMS) at Rochester Institute of Technology (RIT). Southworth is the author of *Color Separation Techniques* (3rd Edition, 1989), the *Pocket Guide to Color Reproduction* (2nd Edition, 1987) and *Quality and Productivity in the Graphic Arts* (1989, with Donna Southworth). He is a director of the International Association of Graphic Arts Consultants. Since 1981, Miles and Donna Southworth have published a monthly newsletter called *The Quality Control Scanner*.

Thad McIlroy
Thad McIlroy is a desktop publishing consultant and writer, and president of The Color Resource. He is also president of Arcadia House, a consulting firm based in San Francisco. Arcadia House specializes solely in the area of desktop publishing and its application in the professional graphic arts industries. McIlroy is the co-author of *Desktop Publishing in Black & White and Color* and *Desktop Publishing: A Primer for Printers*. McIlroy is a contributing editor to *Printing Impressions*, *Pre-* and *Desktop Communications* magazines and the International Prepress Association's *Prepress Bulletin*. He is a director of the International Association of Graphic Arts Consultants.

Donna Southworth

Donna Southworth has been vice president of Graphic Arts Publishing Inc. since its establishment in 1976 and is an officer in The Color Resource. She manages most functional areas of these publishing businesses. Working closely with Miles Southworth and Thad McIlroy, Donna Southworth is actively involved in the writing, editing and publishing of literature for the graphic arts industry. Keeping abreast of technology, she attends trade shows and association meetings and has visited many domestic and international printing schools and businesses.

About The Color Resource

The Color Resource is a new publishing company dedicated to informing, training and supporting people who create and process color images for desktop publishing and the graphic arts. The company publishes and distributes books, newsletters and audio/visual materials.

For more information, contact The Color Resource at:
> 3100 Bronson Hill Road
> Livonia, NY 14487
> (716) 346-2776
> Fax (716) 346-2276